The Qin Terracotta Army

TREASURES OF LINTONG

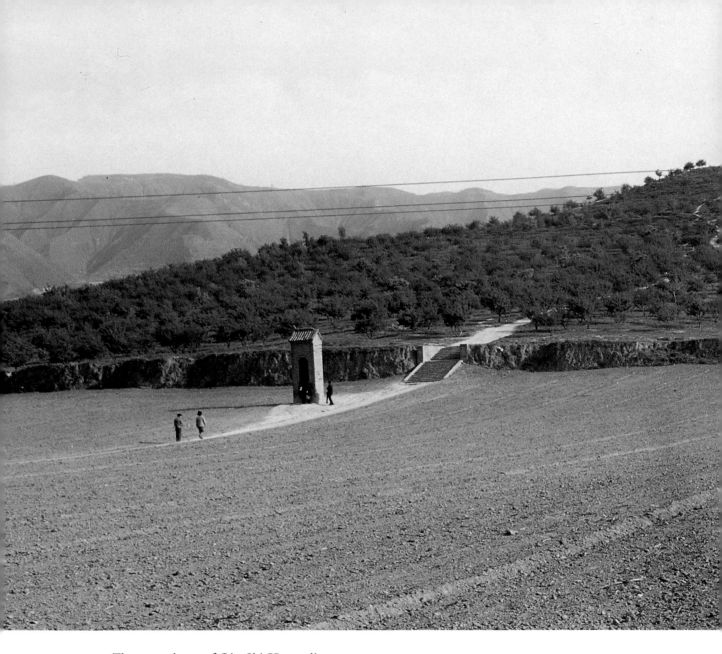

The mausoleum of Qin Shi Huangdi

The Qin Terracotta Army

TREASURES OF LINTONG

Zhang Wenli

SCALA BOOKS

AND

CULTURAL RELICS PUBLISHING HOUSE

© 1996 Text and illustrations: Cultural Relics Publishing House
© 1996 Layout and design: Philip Wilson Publishers Limited
and Cultural Relics Publishing House

First published in 1996 by Scala Books
an imprint of Philip Wilson Publishers Limited
143-149 Great Portland Street
London W1N 5FB

Reprinted 1998, 1999

Distributed in the USA and Canada by
Antique Collectors' Club
Market Street Industrial Park
Wappingers' Falls, New York 12590

ISBN 0 85667 450 8

Translated from Chinese by Li Tianshu, Du Qimei,
Zhang Siying, Chen Haiyan
Designed by Langley Iddins
Consultant English editor and translator: Susan Whitfield
English translation edited by Sally Prideaux
Colour origination by Shekou Yilin Graphic Arts Co Ltd, Shenzhen
Printed and bound in Hong Kong by
China Translation & Printing Services Limited

CONTENTS

Chronology of Dynasties and Major Events

c.1600–1066 BC	**SHANG DYNASTY**
c.1066–771	**ZHOU DYNASTY**
c.1066–771	**Western Zhou**
770–221	**Eastern Zhou**
770–476	Spring and Autumn Period
475–221	Warring States Period
259 BC	Birth of Ying Zheng, the future Qin Shi Huangdi
247 BC	King Zhuang Xiang dies; his son Ying Zheng succeeds to the throne with a regent. The building of a mausoleum of King Ying Zheng begins.
238 BC	King Ying Zheng takes over the reins of the state and suppresses the rebellion of the nobles.
230 BC	King of Han offers to submit to Qin.
228 BC	Qin conquers Zhao.
226 BC	Qin conquers Yan.
225 BC	Qin conquers Wei.
224 BC	Qin conquers Chu.
221 BC	Qin conquers Qi. The unification of China. King Ying Zheng declares himself 'First Emperor of the Qin' (Qin Shi Huangdi). Standardization of Chinese characters, currency, weights and measures.
221–206 BC	**QIN DYNASTY**
220 BC	The first imperial tour of inspection, to west China.
219 BC	The second imperial tour of inspection, to east China.
218 BC	The third imperial tour of inspection, to east China. First attempted assassination of Qin Shi Huangdi.
216 BC	Second attempted assassination of Qin Shi Huangdi.
215 BC	The fourth imperial tour of inspection.
213 BC	Burning of the books.
212 BC	Burying alive of the Confucian scholars.
210 BC	Fourth imperial tour of inspection during which the emperor dies. The announcement of his death is delayed until the return to the capital because of fear of rebellion. It is high summer and the smell of his decaying body is disguised by the addition of a cartload of fish to the entourage. He is buried at the foot of Li Mountains, east of the Qin capital, Xianyang.
209 BC	Hu Hai, Qin Shi Huangdi's son, succeeds to the throne. Chen Sheng, a farmer, leads a peasant uprising.
208 BC	Chen Sheng's rebel army reaches Lintong. Zhang Han leads the convicts constructing the emperor's tomb in suppressing the peasant uprising.
207 BC	Liu Bang's troops enter the Qin capital.
206 BC	Qin is overthrown. Xiang Yu enters Shaanxi, burns Qin palaces and pits of the terracotta army and robs the Qin mausoleum.
206 BC–AD 220	**HAN DYNASTY**
206 BC–AD 24	**Western or Former Han**
25–220	**Eastern or Later Han**
195 BC	Emperor Gaozu of the Han dynasty orders that twenty households move to the necropolis to guard Qin Shi Huangdi's tomb.

220–265	**THREE KINGDOMS (Wei, Shu and Wu)**
265–589	**SIX DYNASTIES**
386–581	**NORTHERN DYNASTIES**
581–618	**SUI DYNASTY**
618–907	**TANG DYNASTY**
907–960	**FIVE DYNASTIES**
907–1125	**LIAO DYNASTY**
960–1279	**SONG DYNASTY**
960–1126	**Northern Song**
1127–1279	**Southern Song**
970	Emperor Taizu of the Song dynasty orders that Lintong County protect and restore the Qin mausoleum.
1115–1234	**JIN DYNASTY**
1279–1368	**YUAN DYNASTY**
1368–1644	**MING DYNASTY**
1644–1911	**QING DYNASTY**
1912–1949	**REPUBLIC OF CHINA**
1949–	**THE PEOPLE'S REPUBLIC OF CHINA**
March 1961	The State Council lists the Emperor Qin's tomb as a national historical site for state protection.
March 1961	Shaanxi Administration Bureau of Cultural Relics Preservation makes an extensive survey of the tomb.
Winter 1973	The discovery of the site of stone-processing pit of the Qin tomb.
March 1974	Local peasants find the terracotta figures while sinking a well.
June 1975	Discovery of the site of Qin tomb's fish pond.
February 1976	Discovery of bells in the Qin tomb.
April 1976	Discovery of coins near the tomb.
May 1976	Discovery of terracotta figures of Pit 2.
June 1976	Discovery of Pit 3.
October 1976	Discovery of a Qin satellite tomb in Shangjiao village, Lintong County.
October 1976	Discovery of the ruins of the construction site No.1 north of the Qin tomb.
March 1977	Discovery of the ruins of the construction sites Nos 2, 3 and 4 north of the Qin tomb.
July 1977–March 1978	Discovery of the rare birds and animals pit of the Qin tomb.
December 1979	Discovery of the builders' tombs of the Qin mausoleum.
December 1980	Excavation of the bronze chariots and horses of the Qin mausoleum.
Winter 1981	Excavation of the site of a palace of the mausoleum.
1981–1982	Discovery of a high proportion of mercury in the mound of the mausoleum.
December 1985	Discovery of a stable pit in the east outer wall of the mausoleum.
March 1986	Excavation of Pit 1 after five years' suspension, the plan of five test pits covering 2,000 sq. metres.
September 1986	Discovery of Lishan Qianfu pottery plate.
December 1987	UNESCO lists the mausoleum in the World Heritage of Human Beings.
December 1988	Excavation of Pit 3.
September 1989	Pit 3 is open to the public
March 1994	Excavation of Pit 2.
October 1994	Pit 2 is open to the public while being excavated.
August 1995	Discovery of the ruins of five construction sites of the Qin tomb while expanding the road in Lintong County.

1. View of the Museum of the Qin Terracotta Warriors and Horses and Qin Shi Huangdi's mausoleum

Located at the foot of the Li Mountains almost 36 km east of Xi'an, the museum occupies an area of about two million square metres. It consists of three exhibition halls covering the pits containing the terracotta warriors, an exhibition hall displaying the bronze horses and chariots, and several smaller halls of exhibits and other buildings. The museum opened on 1 October 1979. The mausoleum (to the left of the picture) is surmounted by a mound of rammed earth shaped like a truncated pyramid.

A Guide to Qin Shi Huangdi's Mausoleum and the Museum of the Qin Dynasty Terracotta Warriors and Horses

The Museum of the Qin Dynasty Terracotta Warriors and Horses (plate 1) lies about 36 kilometres east of the town of Xi'an at the foot of the Li Mountains (Lishan) (plate 2). A newly built main road leads to this large museum complex which houses over 7,000 terracotta statues of soldiers and horses over 2,000 years old.

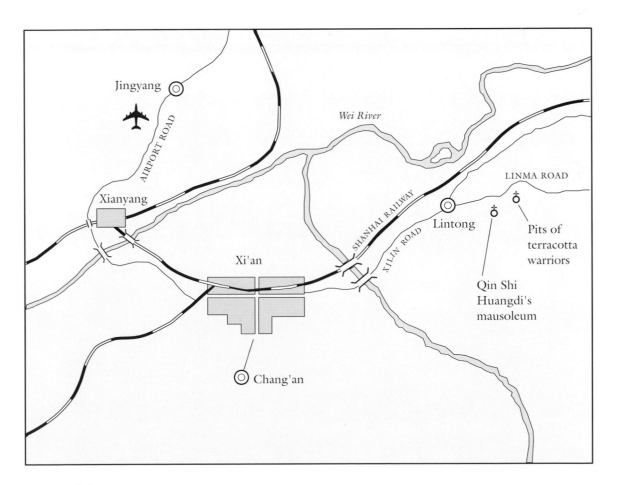

2. Map of the area

The Museum of the Qin Terracotta Figures

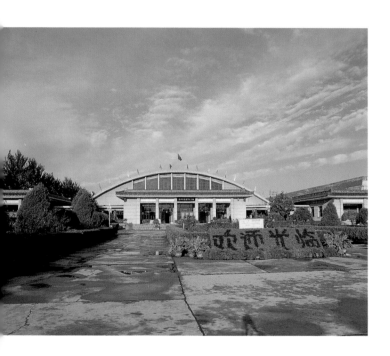

3. View of Pit 1 exhibition hall
The hall was started in 1976 and
took three years to complete.
It is steel structured without
supporting pillars and most of the
roof is made from large glass
plates, thereby allowing the
terracotta figures to be viewed
by natural light.

The first pit containing terracotta figures
was discovered in early 1974. In 1975 the
State Council decided that a museum be
built over the original excavation site and
after four years exhibition halls and several
auxiliary buildings had been built. Two
other pits with figures had come to light in
1976 (a fourth pit was uncompleted and is
empty). The museum was opened on
1 October 1979.

The museum covers an area of two mil-
lion square metres and has been planted
with trees and flowers. The exhibition hall
covering the main pit (Pit 1) is a large
arched structure (plate 3), while those cov-
ering Pits 2 and 3 are shaped like truncated
pyramids, in imitation of the shape of
Chinese tombs dating from that time
(plates 4, 49). The walls of the exhibition
halls are faced with granite. There are a
number of other buildings in the complex,
including the exhibition hall for the bronze
chariots, a reception hall, a general exhibi-
tion hall, and buildings housing the
restoration department, study areas, and
other reception and service facilities.

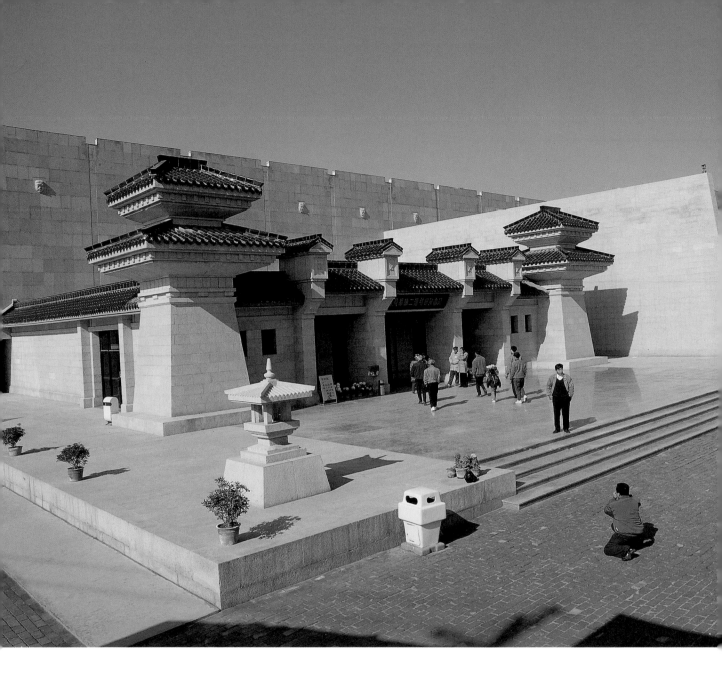

**4. Exterior of the exhibition hall
of Pit 2**
Although built of steel, the architec-
ture of this hall emulates Qin and
Han dynasty styles.

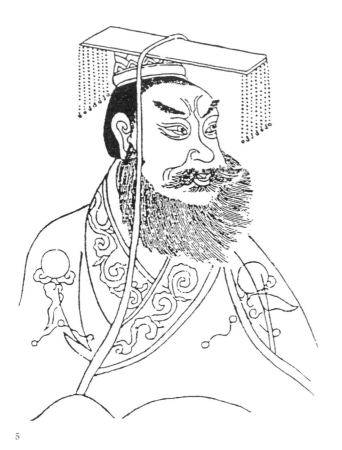

5

Emperor Qin Shi Huangdi's Mausoleum and the Discovery of the Terracotta Warriors

THE EMPEROR QIN SHI HUANGDI

The terracotta warriors are in satellite pits almost 1.5 kilometres east of the emperor Qin Shi Huangdi's mausoleum (plate 1). Qin Shi Huangdi (plates 5–6) was the first emperor of China. He became king of the state of Qin in the area around present-day Xi'an in 247 BC at the age of thirteen. At this time, China was divided into many contending states or kingdoms, hence the period is often referred to as the 'Warring States'. By 230 BC seven states had achieved dominance and in the next decade Qin, under the rulership of the young king, conquered the other six to unify China in 221 BC (plate 7). It is suggested that the pits of warriors were placed to the east of the mausoleum to protect the emperor

5. Depiction of Qin Shi Huangdi
This depiction of Qin Shi Huangdi is a woodcut in *Sancai tuhui* (assembled pictures of the three realms), a work compiled between the Jiaqing and Wanli reign periods (1522–1620), Ming dynasty.

6. Depiction of Qin Shi Huangdi
Painted by the contemporary artist Liu Danzha.

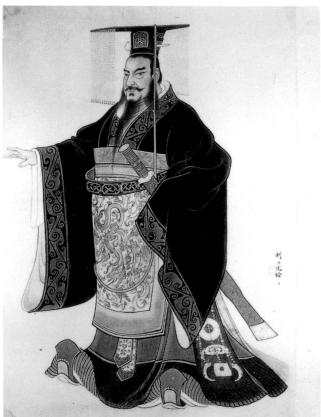

6

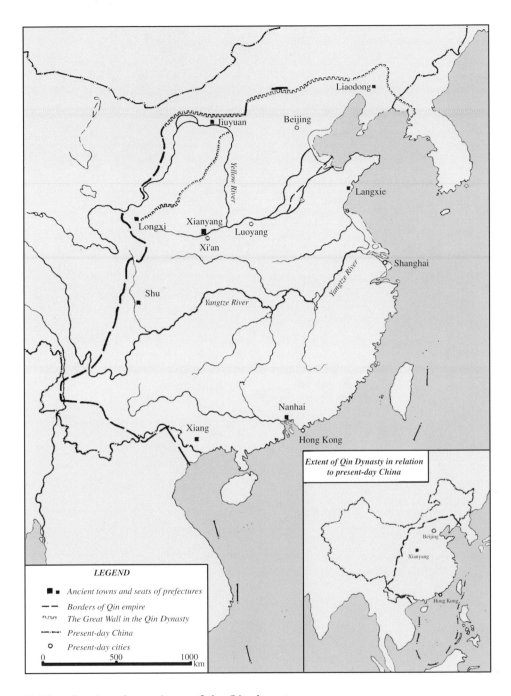

LEGEND

■ ▪ Ancient towns and seats of prefectures

- - Borders of Qin empire

⌐⌐⌐⌐ The Great Wall in the Qin Dynasty

-·-·- Present-day China

○ Present-day cities

0 500 1000
km

Extent of Qin Dynasty in relation to present-day China

7. Map showing the territory of the Qin dynasty

against the six states, which were all to the east of Qin.

To commemorate his unprecedented power as head of the newly unified land, the king took the title of the 'First Emperor of the Qin dynasty' (Qin Shi Huangdi). He instituted a powerful, centralized government based on the political philosophy now known as 'legalism' because of the dominant role of the law in government. Its main tenets were to centralize power in the hands of the emperor and to control the populace by the use of reward and punishment. The Qin dynasty passed laws to standardize the written language, currencies, weights and measures, which had previously differed among the states. However, Qin Shi Huangdi's reign is remembered in China largely for his autocracy. He banned and burnt all Confucian works and is also alleged to have put many hundreds of Confucian scholars to death. Two assassination attempts attest to his unpopularity during his lifetime.

His reign as emperor lasted until 210 BC. Although succeeded by his son, the Qin dynasty was overthrown within a few years after Qin Shi Huangdi's death.

THE MAUSOLEUM OF EMPEROR QIN SHI HUANGDI

Qin Shi Huangdi's mausoleum is situated 35 kilometres east of Xi'an in Lintong county (plate 2). Chinese historical records tell us that building was started as soon as the future emperor became king of Qin at the age of thirteen (plate 8). A site was chosen which fulfilled the geomantic requirements of mountains behind and a river in front, and the tomb is therefore placed between the Li Mountains to the south and the River Wei to the north. After the unification of the country in 221 BC the project was increased in scale and, the histories record, over 700,000 men from all parts of the empire were conscripted as labourers. The work continued even after the emperor's death taking, in total, 38 years. The fact that one of the satellite pits of the terracotta army, Pit 4, is unfinished and therefore empty suggests that the planned work was not completed. A description of the tomb is given in the first great history of China, written in the century after Qin Shi Huangdi's reign.

> The tomb vault was dug through three underground streams and the coffins were cast in copper. Palaces were built within the burial mound and the burial chamber itself was a rich repository full of precious and rare treasures. Artisans were commanded to contrive gadgets controlling hidden arrows so that if tomb robbers approached they would be bound to touch the gadgets and so trigger the arrows. On the floor of the vault mercury representing the rivers and seas was

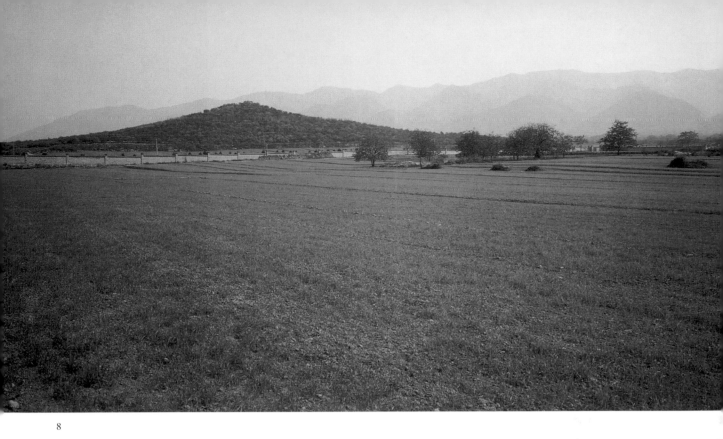

8

8. View of the mausoleum of Qin Shi Huangdi

Qin Shi Huangdi, the 'First Emperor', ordered work to start on his tomb as soon as he came to the throne as King of the State of Qin in 246 BC. The work was expanded on his becoming emperor in 221 BC but was still uncompleted at his death in 210 BC. It is the largest imperial tomb in China and is famous for the great number of burial objects found in its vicinity, although the tomb itself has not been excavated.

9

10

9. Iron tools

Iron tools used by the workers on the site were found in the earth layer above Pit 1 of the terracotta warriors. Remains of the workers' huts were discovered on the south side of the pit.

10. Iron hammer head

kept flowing by mechanical devices. The dome of the vault was decorated with the sun, moon and stars, and the ground depicted the nine regions and five mountains of China. Special fish oil was used to fuel the lamps so that they would burn for a long time.

At the entombment the Second Emperor decreed that it was not fitting that the childless concubines of the First Emperor should be allowed to leave the imperial palace and should all be buried with the Emperor. Thus the number of those who died was very great. After the funeral ceremony, first the inner passage of the tomb was blocked and then the outer passages were completely sealed so that not one of the artisans remained alive. Finally the mound was planted with grass and trees to make it resemble a hill.

Archaeologists have been investigating the site since the 1960s although the tomb chamber itself has yet to be excavated. The layout of the mausoleum precincts was a copy of the Imperial Palace in the Qin capital Xianyang (north of present-day Xi'an). The base of the mausoleum measures 345 metres from east to west and 350 metres from north to south, surmounted by a mound of rammed earth shaped like a truncated pyramid which now stands 76 metres high. The mound was orginally enclosed within two walls. The inner wall measured 1,355 metres from north to south and 580 metres from east to west with a circumference of 3,870 metres. The outer wall was 2,165 metres from north to south and 940 metres from east to west with a circumference of 6,210 metres. The walls no longer exist but the foundations, which are up to eight metres in width, have remained. Both the outer and inner walls had a gate with gate towers on each side, apart from the north side of the inner wall which had two gates (plate 11). Both inner and outer walls had watch towers at the four corners. Between the inner and outer walls the remains of large palaces have been found which were probably the residences of permanently settled worshippers and funerary attendants who acted as warders of the grave site.

Approximately 400 satellite tombs and pits have been discovered in the vicinity of the mausoleum. Among them is the pit containing the emperor's bronze chariots and horses (plate 119) which symbolizes the journey of his spirit to the world of the dead; various pits containing rare birds and animals indicating the emperor's love of hunting; stable pits depicting the imperial studs; and the three pits containing the terracotta warriors and horses representing the mighty army of the Qin dynasty (plate 17). More than 50,000 important artefacts have been unearthed over the years, many of which are priceless treasures such as the bronze chariots and horses (plates 121, 128), terracotta kneeling archers, an imperial bell, and large dragon-patterned tiles. The wealth of the satellite pits and the description of the underground palace in historical records suggest that the mausoleum is a representation of the Qin empire, intended to provide Qin Shi Huangdi after death with all the splendour and might he enjoyed during life.

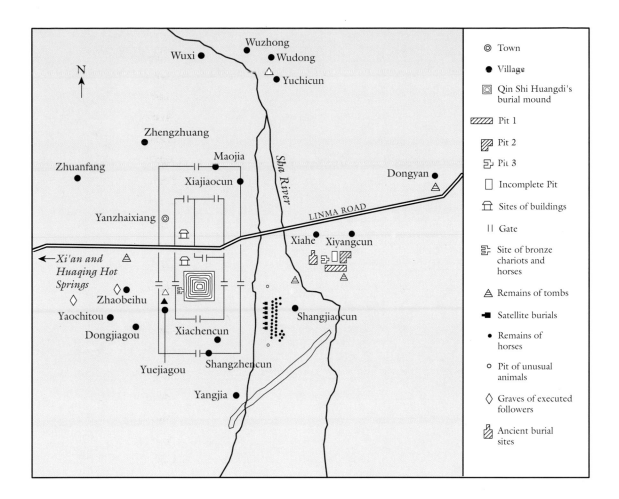

The legend of the map reads:

◎ Town
● Village
▣ Qin Shi Huangdi's burial mound
▨ Pit 1
▧ Pit 2
⊟ Pit 3
▢ Incomplete Pit
⌂ Sites of buildings
‖ Gate
⊟ Site of bronze chariots and horses
△ Remains of tombs
◼ Satellite burials
● Remains of horses
○ Pit of unusual animals
◇ Graves of executed followers
▨ Ancient burial sites

11. Plan showing the position of Qin Shi Huangdi's mausoleum and the pits of terracotta warriors

The pits containing the terracotta warriors and soldiers are located almost 1.5 km to the east of the mausoleum. There are three pits containing figures. Pit 4 was not completed and contains no figures.

On assuming the title of 'First Emperor' in 221 BC, Qin Shi Huangdi declared that 'our successors shall be known as the Second Emperor, Third Emperor, and so on, for endless generations', yet only three years after his death the Qin dynasty was overthrown. Rebellious peasants pillaged and burnt those buildings connected with the Qin dynasty, which was hated for its cruelty. The palaces and other buildings within the walls of the mausoleum were destroyed. Only the huge pyramid of the mound survived the devastation, although it is not known whether the tomb has been plundered by later grave robbers. In 1987 the mausoleum was listed by UNESCO as a World Heritage site.

17

HOW THE TERRACOTTA FIGURES WERE DISCOVERED

The story of the discovery of the terracotta army dates back more than two decades. In the early spring of 1974 peasants from Xiyang village, Lintong county were sinking a well outside their village. They came across a layer of hard, burnt red earth three to four metres underground and below this they found fragments of clay figures. Next they discovered a paved floor (plate 24), a number of rusty bronze crossbow mechanisms (plate 15) and many arrowheads (plate 12). They argued among themselves as to whether it was the site of a kiln, a shrine to a village god, or a Buddhist temple.

Fortunately the news of the discovery quickly reached the county town and the head of archaeological work at the Cultural Centre of Lintong county visited the site with several colleagues. They were especially interested in the life-sized clay warriors (plate 13) and took the fragments back to the Cultural Centre to mend and study.

This was not the first time a terracotta figure had been unearthed at this site. An elderly peasant afterwards told of his first

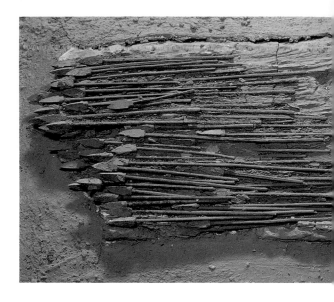

12. Bronze arrowheads from Pit 1
About 100 arrowheads were unearthed from the eastern gallery of Pit 1. The flax quiver has decayed but the bronze arrowheads and wooden shafts have survived. Most Qin dynasty arrowheads, like these, are diamond-shaped for maximum aerodynamic efficiency. The arrows are 70 cm long.

experience of seeing a warrior. It was at the beginning of the Republic of China (1912–49) when he was a child. Again, in the course of sinking a well the villagers dug up a clay figure which they regarded as an object of ill-omen. When they were unsuccessful in finding water they blamed this 'monster' and hung it on a tree outside the village, where it was whipped and

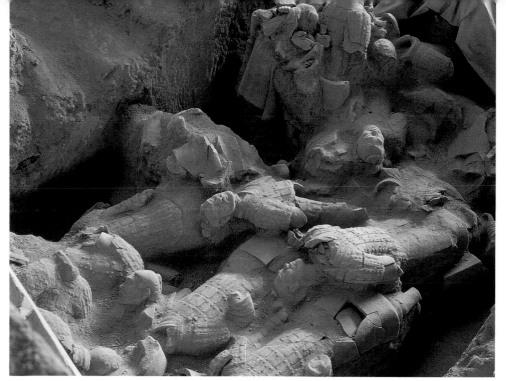

13

13 & 14. Terracotta figures under excavation in Pit 1

Because the roof of the pit was set on fire by the rebelling soldiers at the downfall of the Qin, much of the structure collapsed inwards on to the terracotta army. All the figures are therefore damaged to some extent.

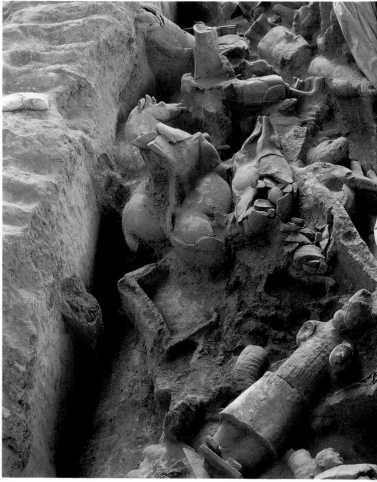

14

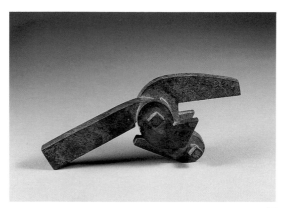

15

15. Crossbow trigger, Pit 1

This bronze crossbow trigger mechanism increased the range of an arrow. It consists of several parts and is 16.1 cm high.

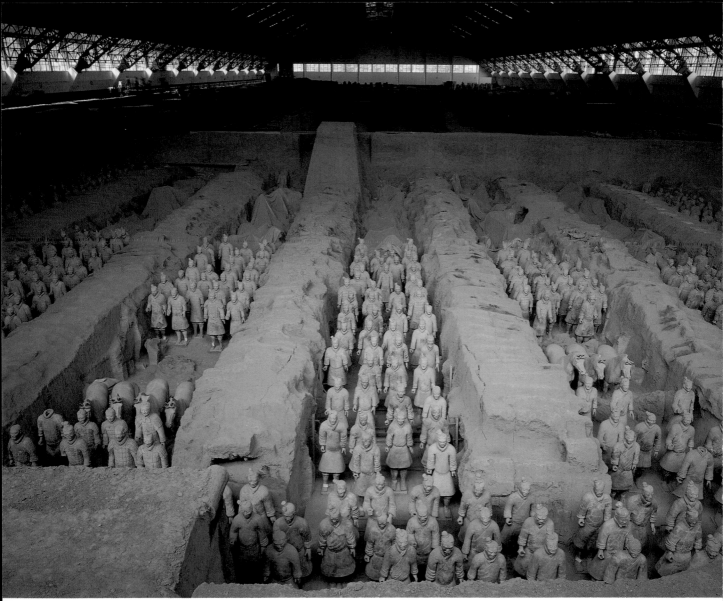

16

left to burn under the sun. Finally it was smashed and reburied deep underground. But the warriors were known about long before this. During the recent excavations a number of small tombs were discovered in the upper layer of the Qin pits. The earliest dates from the Western Han dynasty (206 BC–AD 9), the dynasty immediately succeeding the Qin, while most belong to the Ming and the Qing dynasties (1368–1911). Terracotta fragments were found in the majority of these smaller tombs indicating that the tomb-diggers at the time had reached the terracotta figures.

16. (*above*) **Pit 1 exhibition hall**
The unit in Pit 1 consists of eleven columns of soldiers all facing east with chariots and horses, a vanguard of archers, flanks on either side and a rearguard facing west.

17. (*opposite*) **Layout of Pits 1–3**
All three pits face east.

Coins found in the Western Han tomb were made during the reign of the emperor Wu Di (r. 140–86 BC). It is therefore clear that the terracotta warriors and horses were discovered long ago, although their historical value was not recognized until recently.

Four months after the 1974 discovery by local villagers, the State Administration Bureau of Museums and Archaeological Data, the Xi'an Institute of Archaeology, Chinese Academy of Sciences, and the department in charge of museums and archaeological data in Shaanxi Province jointly decided that all exploration and excavation on this site be carried out under the guidance of this last named department. In July 1974 an archaeological team was sent to the site thus beginning the most important excavation of the century, and as the dig progressed they discovered more and more terracotta figures. Following the discovery of Pit 1 in early 1974, Pits 2 and 3 came to light one after another in 1976. The three pits are arranged in a triangle covering an area of 20,000 square metres (plate 17). In total they contain more than 7,000 terracotta figures and over 100 wooden chariots. The three pits are all underground earth and wood structures. They differ in their structure but all have a similar layout.

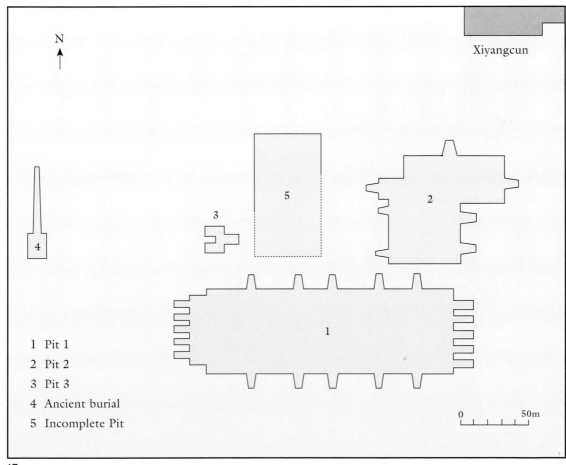

N

Xiyangcun

5

3

4

2

1

1 Pit 1
2 Pit 2
3 Pit 3
4 Ancient burial
5 Incomplete Pit

0 50m

17

The Three Pits of Terracotta Figures

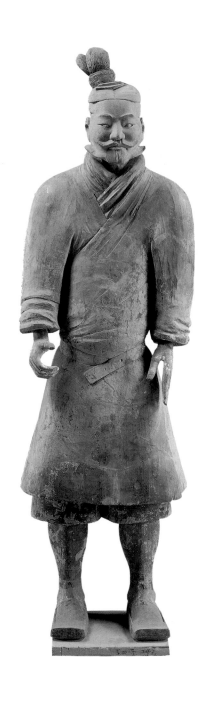

THE GRAND ANCIENT BATTLE FORMATION

The terracotta soldiers and horses in all three pits are arranged in battle formation (plates 16, 19). Pit 1 is the largest (plate 18) measuring 230 metres from east to west and 62 metres from north to south. The oblong battle formation, facing east, is composed of a main body surrounded by a vanguard, two flanks and a rearguard, arranged in the eleven parallel corridors running from east to west and two galleries at the east and west ends. Five earth ramps connect the galleries at each end with the surface. The gallery at the east end of the pit contains a vanguard of 204 warriors standing in three rows of 68 and all facing

18. (*opposite*) **Side view of Pit 1 exhibition hall**
The vanguard in Pit 1 stands in three rows on a raised gallery at the eastern end of the pit. Only three soldiers are wearing armour, and each soldier's hair is arranged in a top-knot. At either end is a commander who wears a distinctive and elaborate cap. Behind them is the body of soldiers.

19. (*opposite*) **Exhibition hall of Pit 1**
Excavation work continues in Pit 1 and over 2,000 terracotta warriors have been put on display to date.

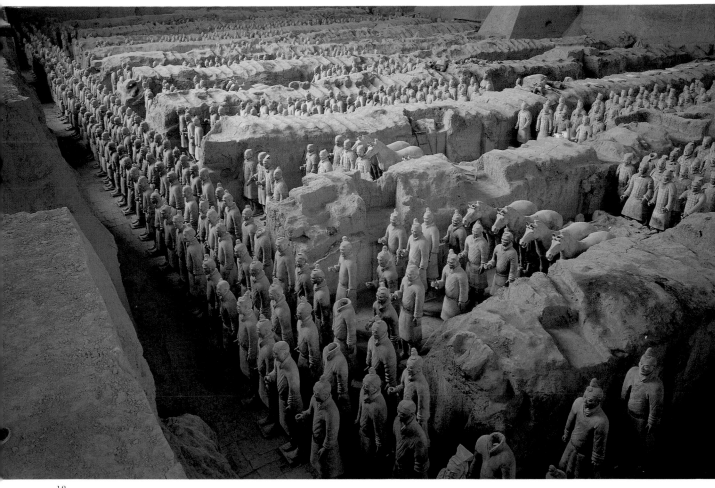

18

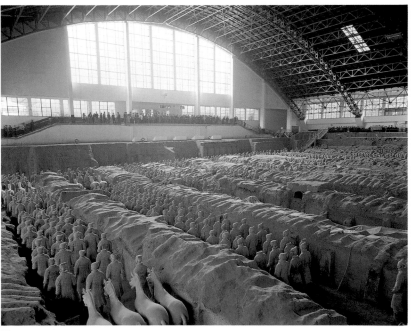

19

20–21. Vanguard in Pit 1

This view of the vanguard on the north side of the pit shows that each warrior is positioned as if holding a bow. The traces of wooden bows and copper arrows found in this area suggest that each originally carried a sheath of arrows on his back, and held a bow awaiting orders.

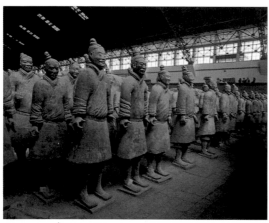

20

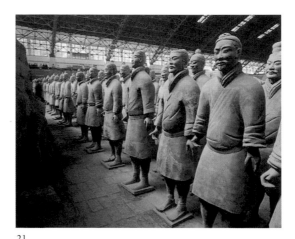

21

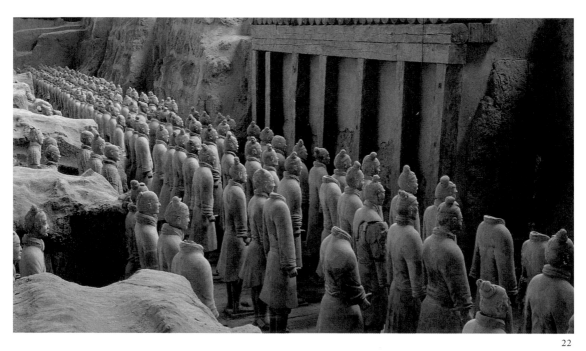

22

22. Rear view of vanguard in Pit 1

This plate shows the vanguard troops on the south side of the pit.

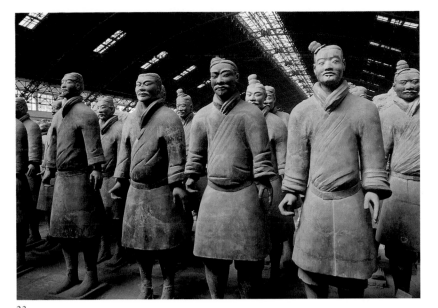

23. Vanguard in Pit 1 (detail)
Shown here are the troops in the middle of the vanguard. The height of the warriors coupled with their square faces, wide foreheads and high cheeks is typical of men from the area known as Guanzhong — the Land Within the Passes (present-day Shaanxi Province).

east (plates 20, 21, 22). Only three of these warriors are in armour, while the remainder are infantry soldiers wearing robes and puttees (plates 23, 24). Most are positioned as if holding bows, the remainder swords and spears. On both the north and south ends of the three rows stands a middle-ranking officer wearing an officer's cap (plate 67, 68).

The warriors occupying the west gallery also consist of three rows of infantrymen, the front two rows facing east and the back row, the rearguard, facing west. They are all clad in armour. On the left and right sides of the pit are two rows of soldiers, the outermost row of each side, the flanks, facing out to the north and south. The main body consists of four columns of infantrymen in each of the nine corridors, the single columns of soldiers on the two side corridors, and the two rows on the back gallery (plates 25-33). There are also four-horse chariots at the east end of six of the corridors (plates 25–27, 30, 32-33).

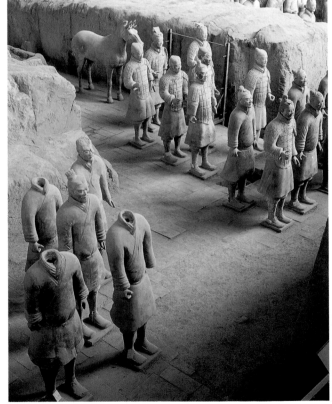

24. The vanguard in front of the third column in Pit 1
The paved floor of the pit can be seen in this picture.

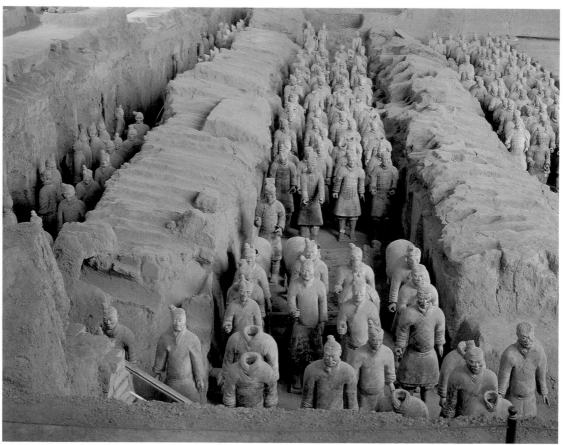

25

25–33. Panorama of the eastern battle unit in Pit 1 (columns 1–11)

The battle unit in Pit 1 comprises over 40 four-horse chariots and about 6,000 terracotta soldiers slightly larger than life size. Behind the three rows of the vanguard are soldiers arranged in 38 columns facing east with flanks consisting of a single column of soldiers on either side facing outwards (north and south). The rearguard also faces outwards (west).

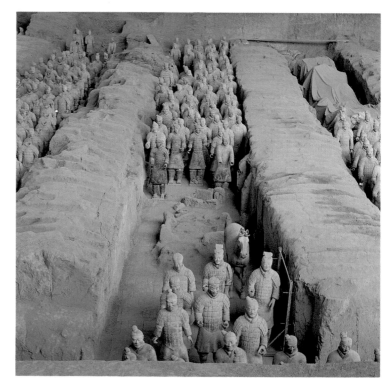

26

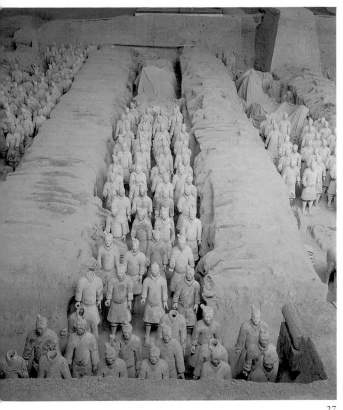

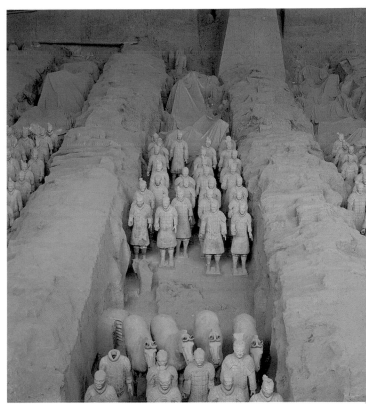

27 28

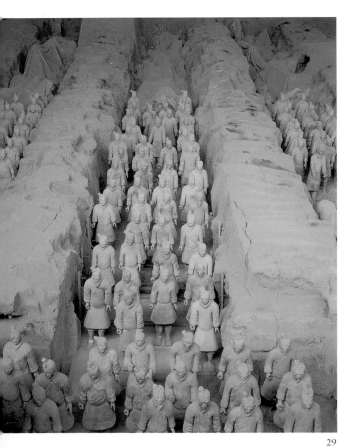

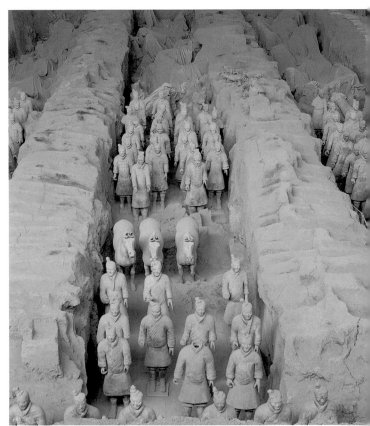

29 30

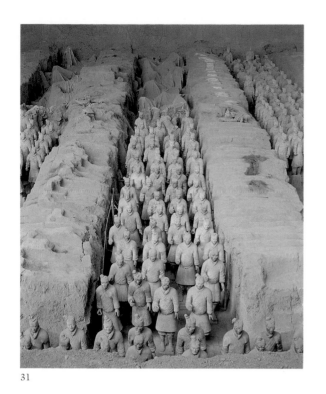

31

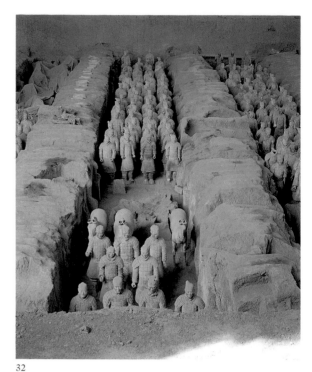

32

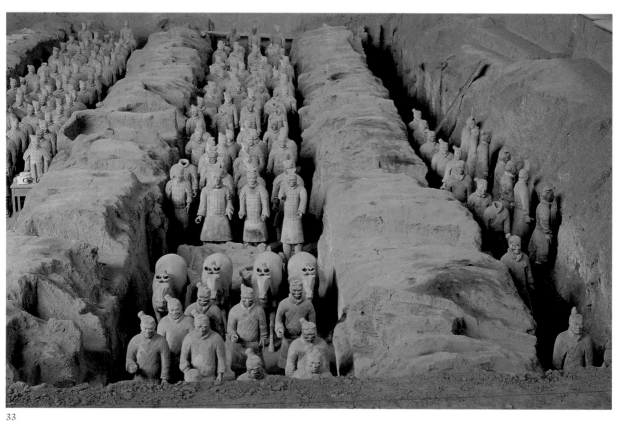

33

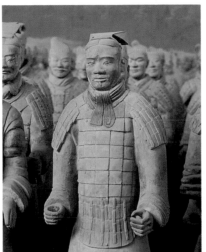

34. Assistant charioteer in tenth column, Pit 1
The chariots carry either three or four people. This chariot has three: the charioteer, an assistant charioteer and a middle-ranking officer. The assistant charioteer would fight and help push the chariot if it stuck in the mud. His cap shows he is ranked above the ordinary soldiers.

34

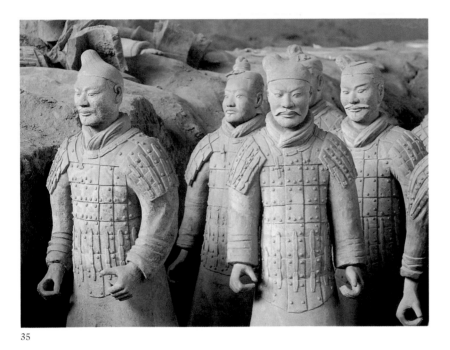

35

35. Warriors in front of the chariot in the ninth column, Pit 1
To the left of this picture is the commanding officer of the column wearing an officer's cap. Traces of paint can be seen on the armour of some warriors.

36 & 37. Terracotta horses being excavated, Pit 1

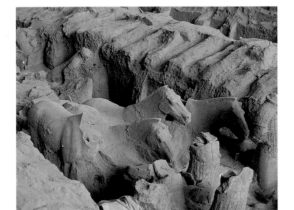

36

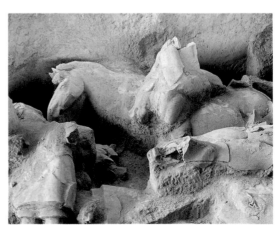

37

38. Excavation site of Pit 2

Pit 2 covers an area of 6,000 square metres. It is estimated that it contains 89 war chariots, 472 horses and 900 warriors although it is still being excavated.

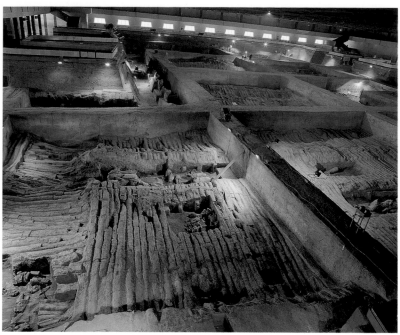

39. Plan of Pit 2

The battle formation in Pit 2 is made up of four units which could either act separately or as one.

38

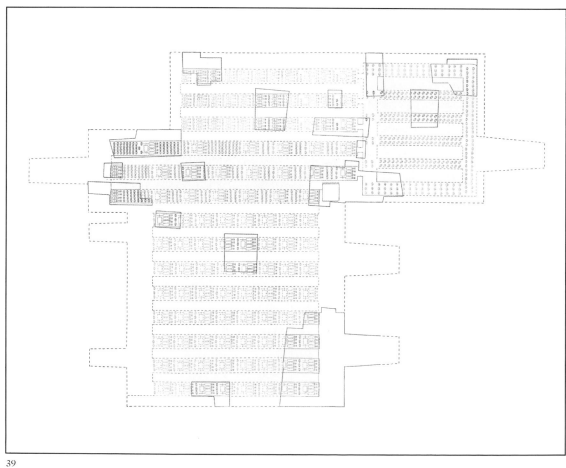

39

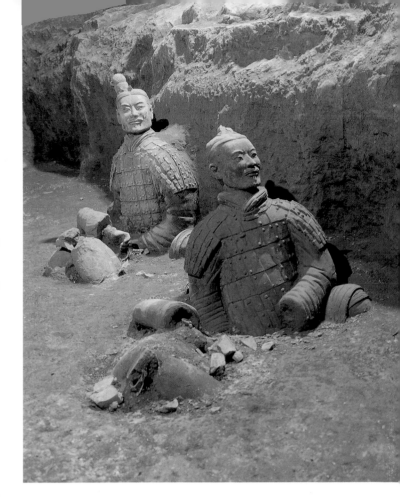

40. Terracotta warriors, Pit 2

Pit 2 (plate 38) has an area of 6,000 square metres and is L-shaped, with the stem of the 'L' facing south. It contains a composite formation of infantry, cavalry and chariot soldiers, consisting of four units (plate 39).

Unit 1 in the east end, the foot of the 'L', consists of 332 infantrymen armed with crossbows and arranged in a square battle formation all facing east, with inner and outer sections. The inner section is made up of eight columns each comprising twenty kneeling archers in armour (plates 85, 86). The outer section is comprised of infantrymen. The front soldiers form two rows of thirty. On both the left and right sides there are three columns of fourteen robed soldiers and at the back stand another two rows of fourteen.

In the south end of the pit is unit 2, a square battle formation of eight columns of war chariots, eighteen in each column and facing east (plate 41). The wooden chariots themselves have all rotted, but traces of their remains in the earth can be seen along with the bronze fittings. Each chariot is pulled by four life-sized terracotta horses, and at the back of the chariot stand three warriors in a row (plate 53).

Unit 3 is in the centre of the pit. It is composed of nineteen four-horse chariots, 264 infantrymen and eight cavalrymen in rectangular battle array, all facing east.

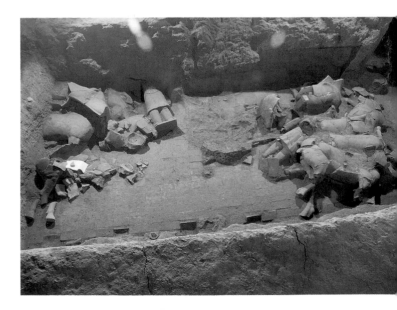

41. Terracotta horses and chariot, Pit 2

31

42. Charioteer, Pit 2
Charioteers, unlike ordinary soldiers, wore armour down to their wrists to protect their arms which were vulnerable while driving the chariot in battle. They also wore distinctive caps with their hair tucked underneath. Eleven chariots from Pit 2 have been unearthed to date with 28 terracotta figures accompanying them. It is estimated, based on what can be surmised of the battle formation from the sections already excavated, that a further 89 chariots and 261 warriors will be unearthed from this pit.

43-45. (*opposite*)
Charioteer with chariot warriors, Pit 2
The charioteer is usually flanked by two soldiers who hold on to the chariot with one hand and wield a lance with the other.

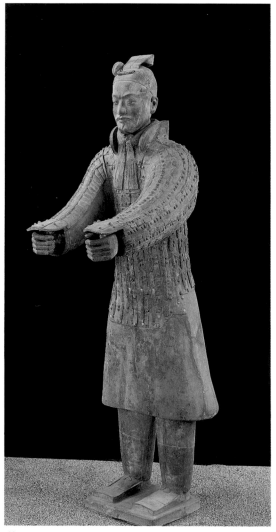

42

On the west side of the pit is unit 4, another rectangular cavalry formation comprising six four-horse chariots, and 108 saddled horses and cavalry (plates 47, 48). This is the earliest and largest group of terracotta cavalry discovered in the history of Chinese archaeology. Four cavalrymen make up a group, three of which form a column. They are armed with crossbows and their horses are fully saddled. They do not have stirrups as these only came into use later.

While the soldiers in Pit 1 appear to be marching into battle, those in Pit 2 seem rather to be at drill or at shooting practice. Cavalrymen are posted at the left rear (the west), ready to attack at any time while on patrol.

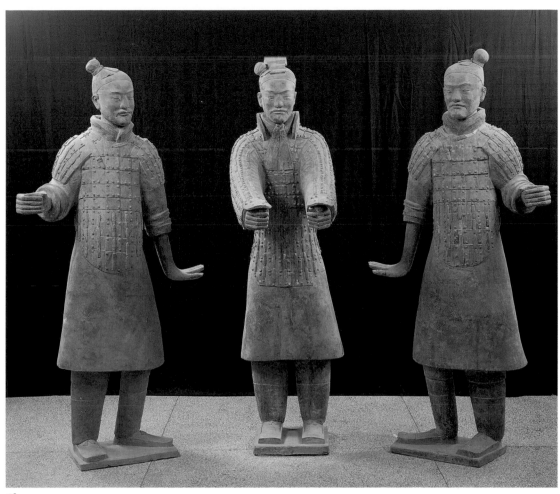

43

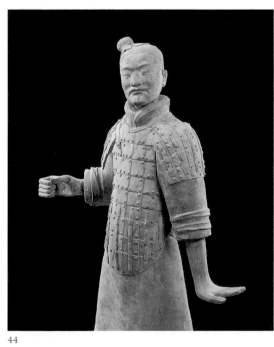

44

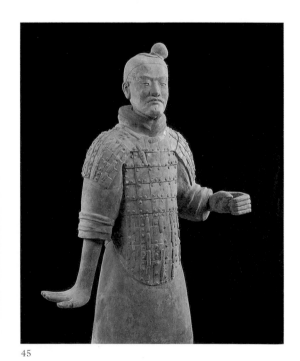

45

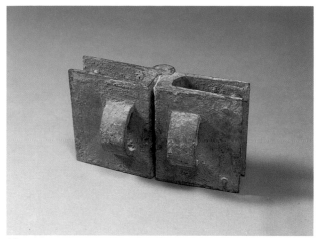

46. Bronze fittings from Pit 2

Traces of wood were found near this bronze fixture although its use is not clear.

46

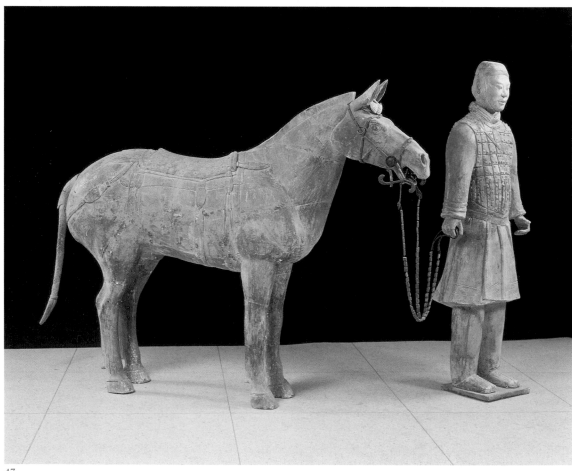

47

34

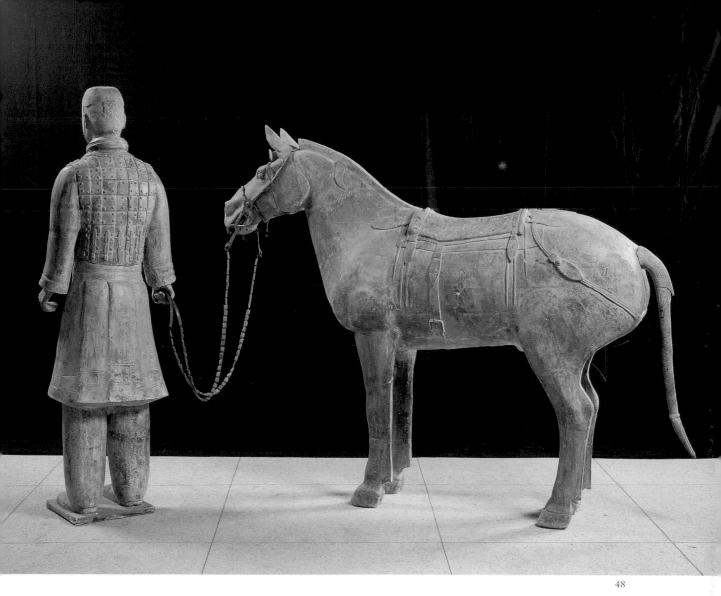

47 & 48. (*opposite and above*)
Cavalryman and horse, Pit 2
Units 3 and 4 in this pit contain a
total of 116 cavalrymen leading
their horses by the reins.

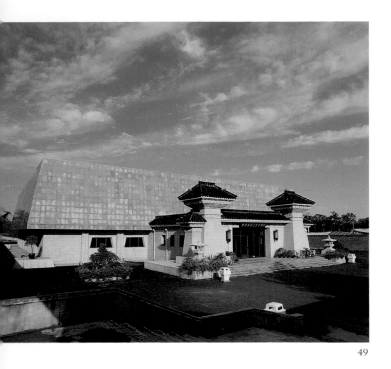

Pit 3 is the command post of the army (plate 49). It covers an area of about 520 square metres, and is U-shaped with the base of the 'U' facing east (plate 50). On its east side is a sloping entrance ramp 11.2 metres long and 3.7 metres wide. A four-horse chariot stands in front of the head-quarters facing the entrance (plates 50, 53–55). Four men accompany the chariot, the charioteer (plate 55) and three officers (plate 53). The stable opposite the entrance is flanked by wing-chambers to the north and south (plate 51).

49. Exterior of the exhibition hall of Pit 3
This exhibition hall has a Chinese-style entrance and was built in 1989. It is now open to the public.

50. Interior of exhibition hall of Pit 3
Pit 3 lies 25 metres west of Pit 1 and is U-shaped, measuring 28.8 metres from east to west and 24.57 metres from north to south. The pit is 5.2–5.4 metres below ground level and has a sloping entrance-way on the eastern side. A chariot with four horses and 66 warriors were found in this pit, most in a poor condition. They have now been renovated.

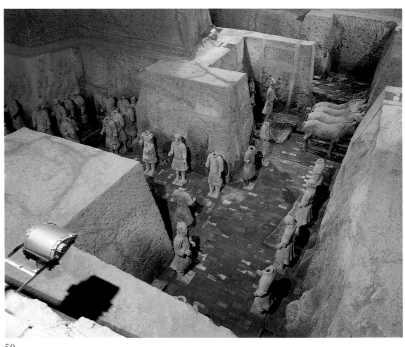

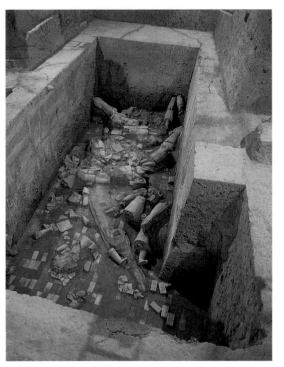

51

51. Excavation of Pit 3
This picture shows the north chamber of the pit which is divided into a lobby and a rear hall and which is 10.4 metres long. Twenty-two warriors in armour were unearthed here standing in two rows facing each other.

52. Rammed earth ruins in Pit 3
As in the other pits, the sides of Pit 3 were strengthened with rammed earth. The picture shows the northern wall of the south chamber.

52

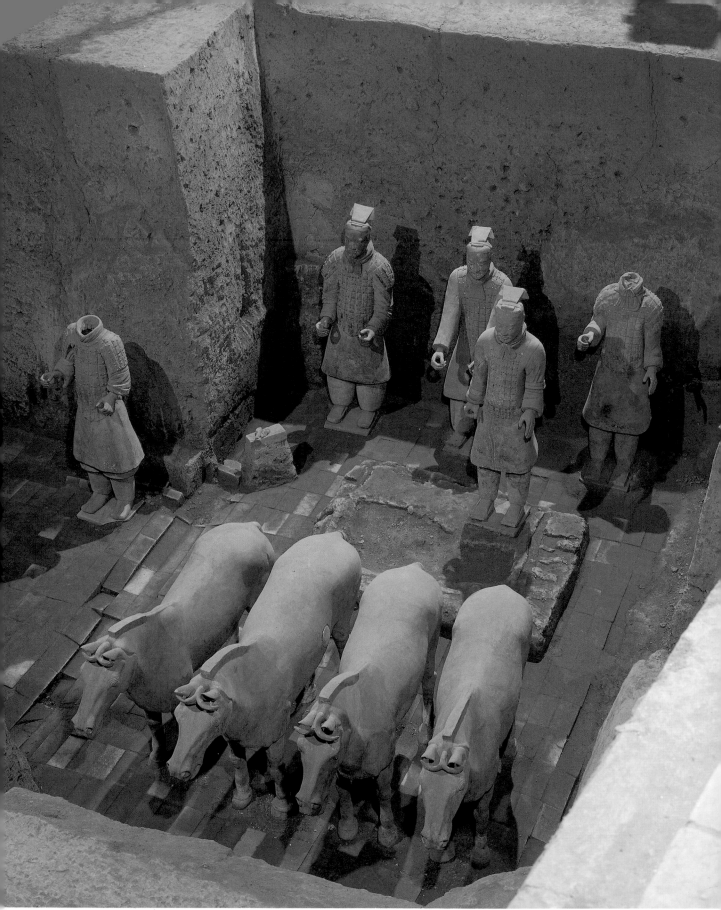

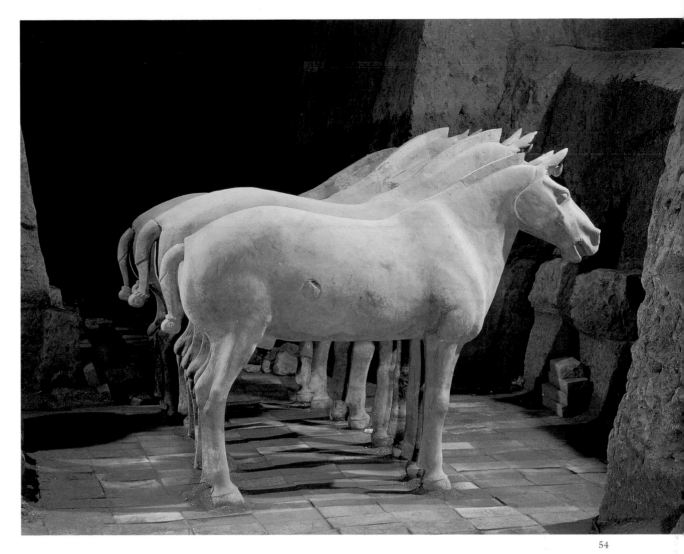

54

53. (*opposite*) **Chariot in Pit 3**
The chariot was discovered opposite the entrance to Pit 3. Four officers accompany the decayed chariot. In the front is an officer. Behind him is the charioteer flanked by two soldiers. The chariot retains traces of paint. It also appears that it had a canopy and is probably the commanding officer's chariot.

54. Horses in Pit 3
The four horses drawing the chariot in Pit 3 are 210 cm long and 172 cm tall.

55. Charioteer in Pit 3
The charioteer is 180 cm tall and is wearing a distinctive cap.

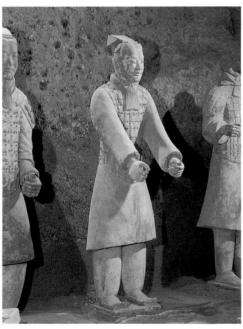

55

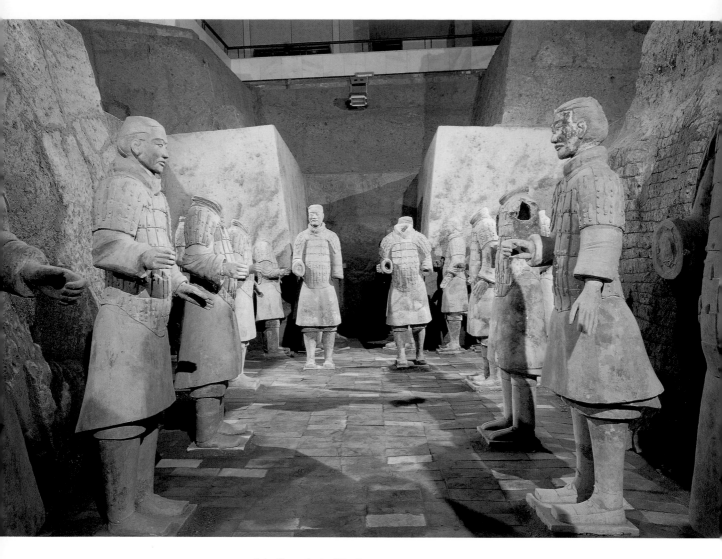

56. Guards in Pit 3
The picture shows warriors in the
corridor of the south chamber of
Pit 3. The corridor, 3.7 metres
long, connected the lobby with the
front and back rooms and contains
six terracotta guards.

The south chamber consists of a lobby, a corridor and front and back rooms with 42 guards standing in facing rows (plates 57, 58). Traces of wooden door lintels were found between the stable and the lobby, and between the front and back rooms, indicating that heavy curtains were hung there to separate the rooms used for planning battle strategy.

The north chamber has a lobby and a rear hall. Remains of the lintel between them can be seen. There are 22 warriors standing facing each other in the hall (plate 51) in which a fragmented deer horn and decayed animal bones were also discovered. This suggests that the hall was used for sacrifices and prayer before battle.

The underground terracotta army formation in these three pits represents the powerful Qin army which succeeded in unifying China for the first time and imposing a centralized regime with Qin Shi Huangdi at its head. It has also provided rich and valuable materials for the study of the Qin military system, especially the battle formations, to supplement and confirm the written record.

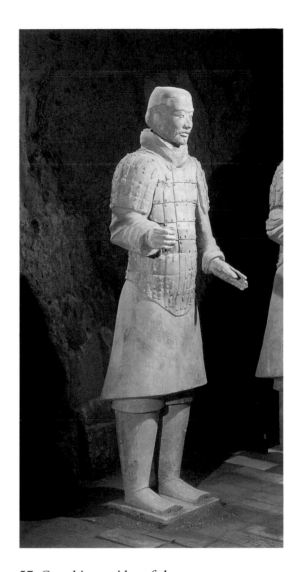

57. Guard in corridor of the south chamber of Pit 3
This figure is 1.80 metres tall. He appears to be holding a sword in his left hand and a long weapon in his right.

59. (*opposite*)
**Rear view of infantry in
the ninth column, Pit 1**
All the soldiers wear armour
except the front three rows
forming the vanguard.

58. Guard in Pit 3
Found in the south chamber
of Pit 3 this warrior wears a
flat hair bun and his hands
are positioned as if he is
holding a long weapon.

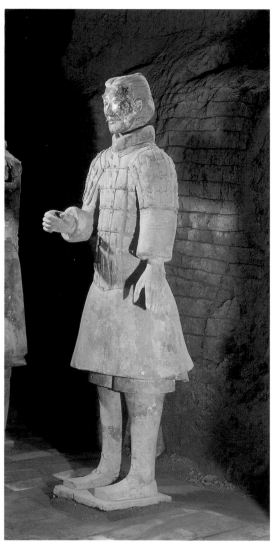

58

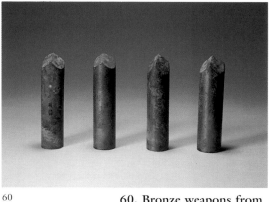

60

**60. Bronze weapons from
Pit 3**
This weapon was used by
guards and most of the war-
riors found in Pit 3 are
equipped with it. The
weapon, 10.5 cm long, is
cylindrical with a pointed
end and would have had a
wooden handle: traces of
this were also found.

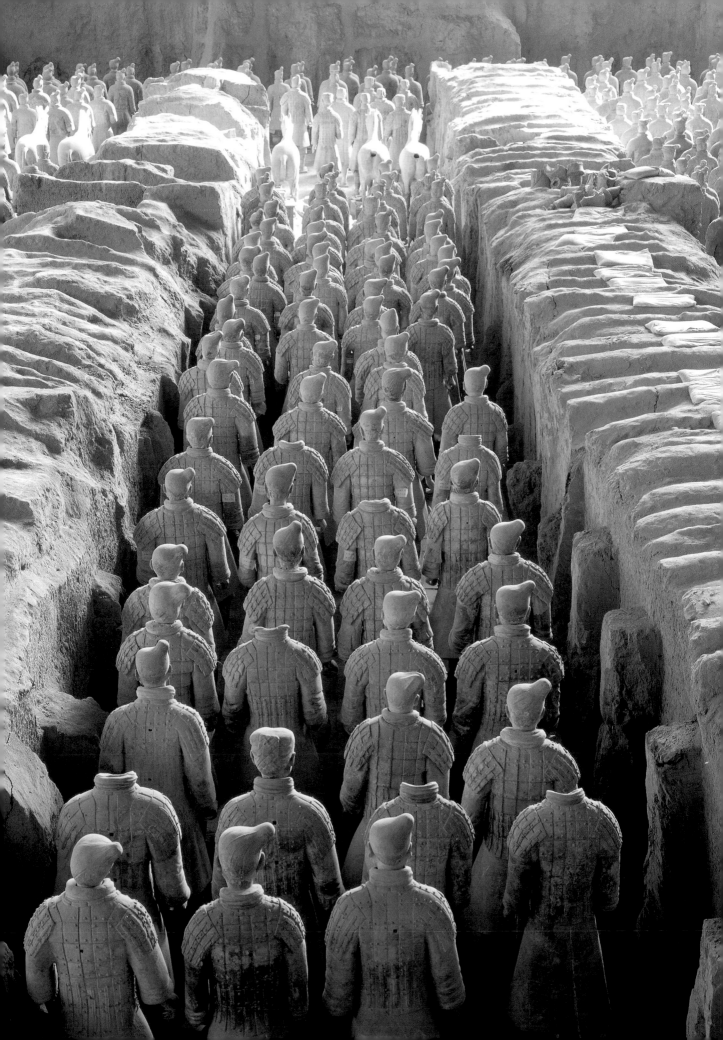

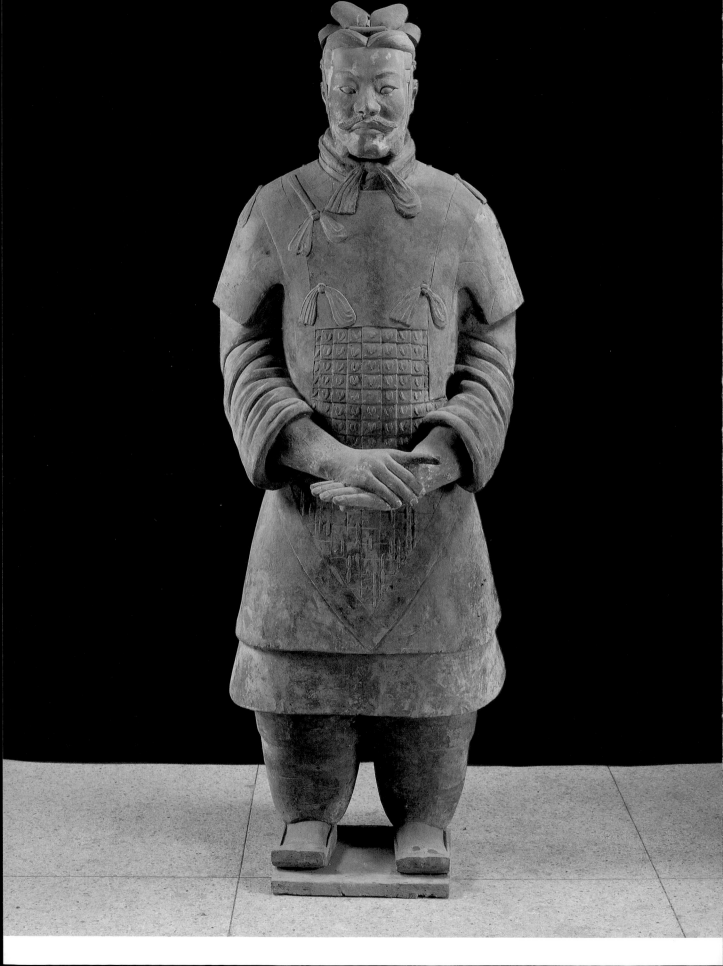

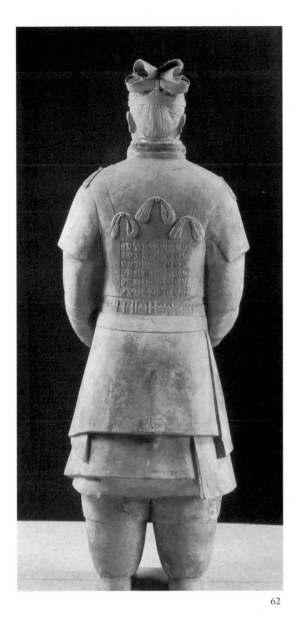

62

61 & 62. (*opposite and above*)
A general, Pit 1 (front and rear views)
This general was riding on the chariot in the second column of Pit 1. Traces of a drum found near the remains of the chariot suggest that he was the general in charge of the drum on which orders were issued. Standing almost two metres tall, he wears two long gowns and armour with leg wrappings, square-toed curled shoes and a general's cap.

EXQUISITE AND REALISTIC CRAFTSMANSHIP

The discovery of the terracotta warriors and horses, the largest sculpture group ever discovered in China, reveals an enormous amount about sculptural art of that time (plates 36, 40, 41).

The warriors can be grouped into three types: generals, officers and ordinary soldiers. All are above life-size — some of the generals, for example, are about two metres tall — and it is said that no two have the same face, suggesting that they were drawn from life. The generals (plates 61–66) are of large build. They wear elaborate caps which would have been adorned with pheasant feathers, square-toed shoes which curl up, trousers which narrow at the ankle, and usually, coloured armour over two robes. The armour covers the shoulders and torso and comes down in a V-shape at the front. The torso armour was made of fixed plates, while the arms (plate 67) and bottom parts used more flexible overlapping mail often called

45

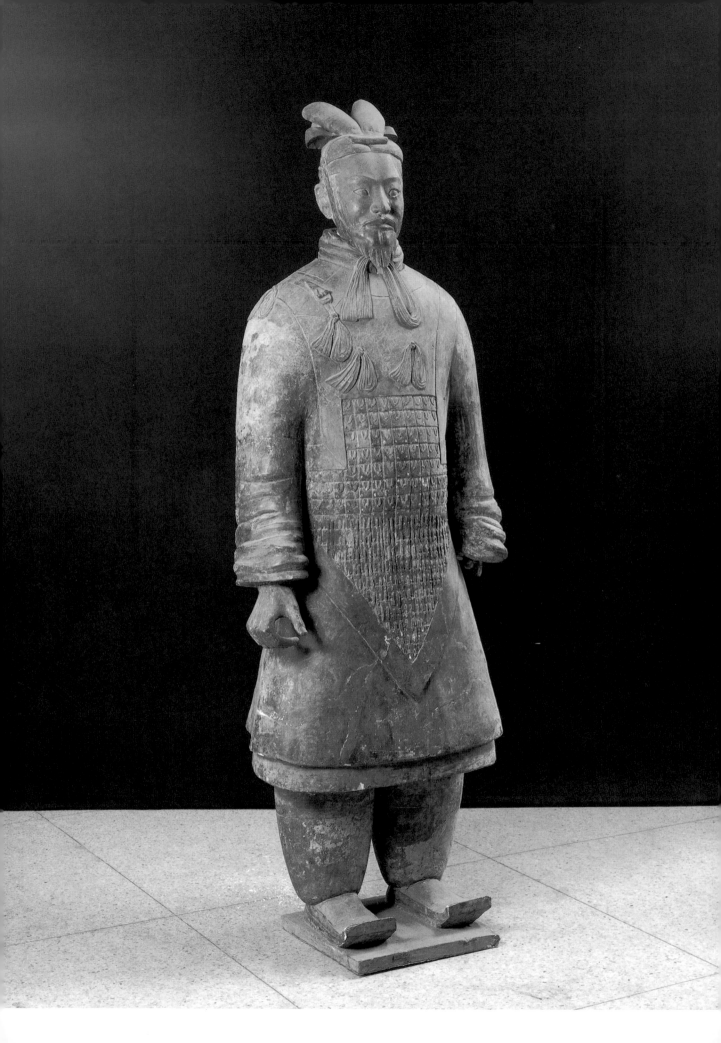

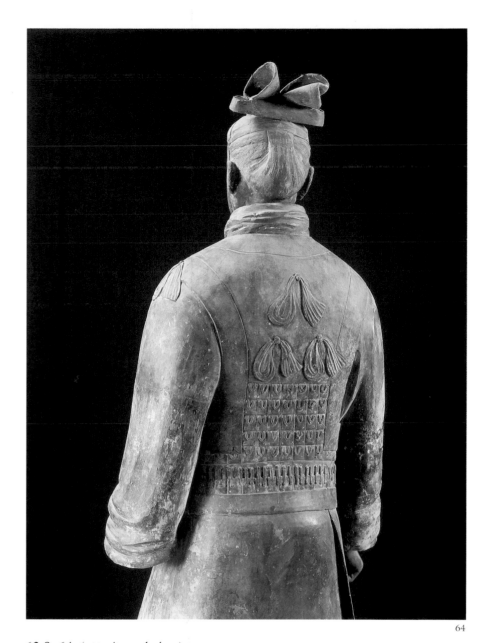

64

63 & 64. (*opposite and above*)
**Terracotta general, Pit 2
(front and rear views)**
This figure was discovered at
the south-west corner of unit 3,
the rectangular formation of
chariots in Pit 2. He is the
commanding officer and wears
a suit of armour over two long
robes and trousers as well as a
general's pheasant-feather cap.

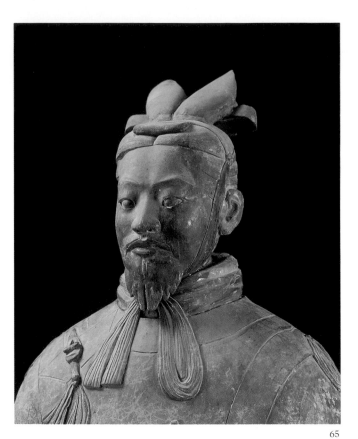

65

65. A general, Pit 2
66. (*opposite*) **A general, Pit 1**
This general, found in the third
column of Pit 1, is 1.91 metres
tall and was riding on the chariot.
He is not wearing armour, but
long trousers tied with a belt, two
robes, curled shoes and a general's
cap with ribbons which tie under
his chin.

'fish-scale armour' because of the shape of
the plates. The armour represented,
remains of which have been found in
tombs and sites dating from this period,
would have been made out of leather or
iron. The tassels on the generals' chests are
badges of rank. They have moustaches and
beards or whiskers and lined foreheads to
represent their age and authority. Some
stand with their hands resting on their
swords stuck into the ground in front of
them (plates 61–62).

The army officers also wear caps (plate
67) and either suits of armour or battle
robes. Their coat of armour is shorter and
of a different design to that of the gener-
als, being comprised of square plates on
which even the rivets are modelled. It
probably represents iron coats of mail
which would have been put on over the
head and fastened with a toggle on the
upper right side of the chest (plate 67),
examples of which have been excavated in
China in recent times. All the warriors
wear thick scarves around their necks,
probably both as protection and to prevent
the armour rubbing. The officers carry
weapons and also have moustaches (plates
67 & 69). The charioteers wear caps of a
different design and generally have armour
which protects their necks and arms down
to their wrists (plates 42 & 71).

The soldiers can be further divided into
infantry, cavalry (plates 47 & 48) and bow-
men (plates 84–86). Cavalrymen also wear
caps which fasten under their chins,
whereas the infantry do not wear any
headgear but have elaborate hairstyles
(plates 75–79).

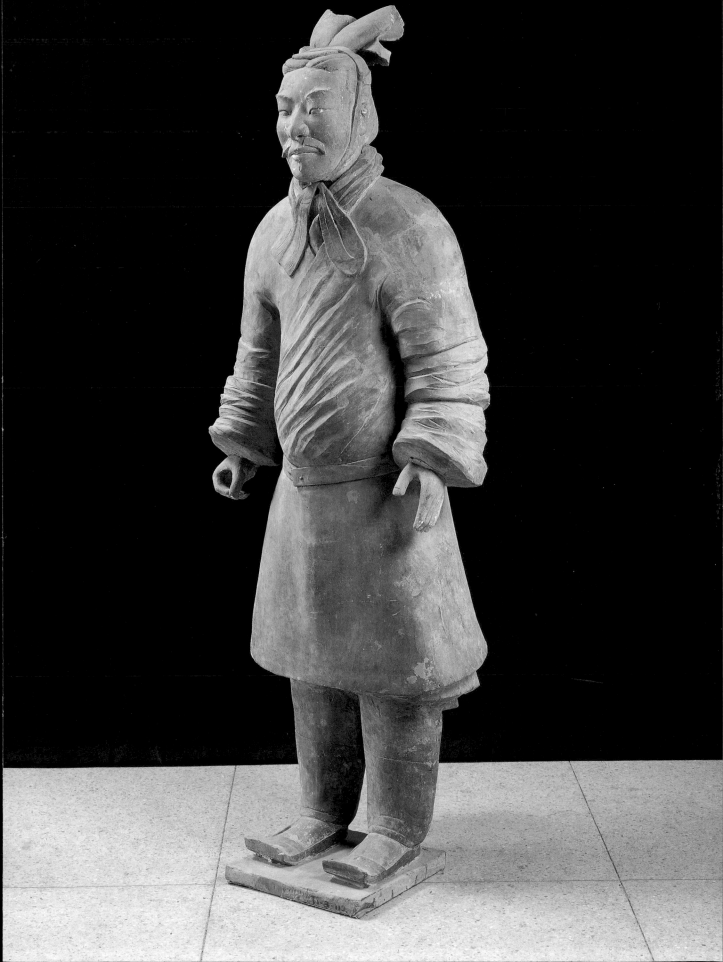

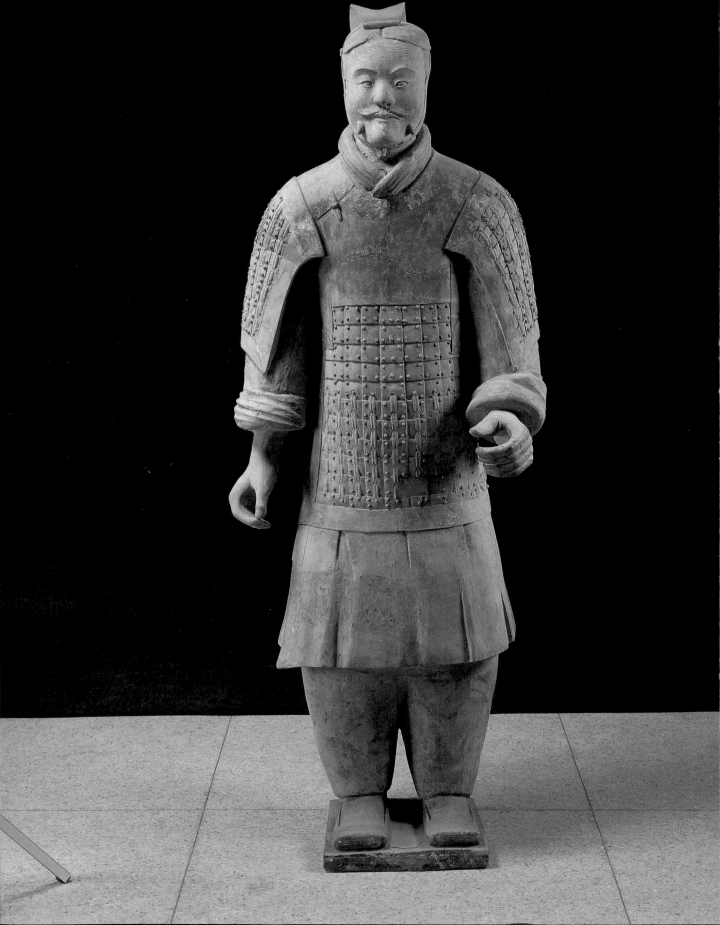

67 & 68. (*opposite and below*)
**Middle-ranking officer,
Pit 1 (front and rear views)**
This officer was found behind
the chariot in the tenth
column of Pit 1. He is 1.89
metres tall and wears a suit of
armour and an officer's cap.
He has a fine moustache and
small beard. Flakes of paint
buried in earth nearby were
still extremely bright when
discovered and indicate that
the officer's hat was painted
a deep red, his robe green
with red-edged collars and
sleeves, his leg wrappings also
green, and his armour a dark
brown with bright red ties.

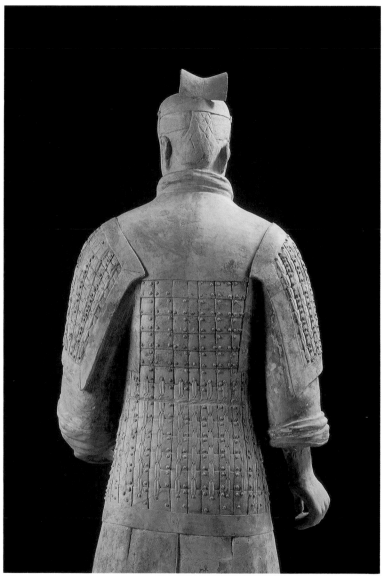

68

69. Middle-ranking officer, Pit 2

At the north-west corner of unit 1, the infantry unit, in Pit 2, stand a general and a middle-ranking officer. The officer, 1.86 metres tall, is wearing a long robe with armour and shin guards. He is holding a sword.

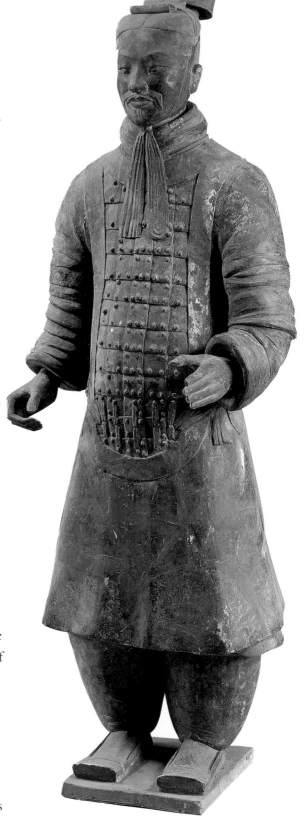

Many soldiers wear their hair in a complicated top-knot in which the hair at the temples was divided and made into two plaits which were then tied to the hair at the back which was made into a long plait. The remaining hair on top of the head and the long plait were then arranged into a high bun on the top of the head, generally to the right. The vanguard in Pit 1 are archers or crossbowmen whose hair is sometimes dressed to the left (plates 75, 85, 86) and wear no armour (plates 20, 23). They would have moved fast and shot at the enemy, each row in turn, from a distance before the armoured infantry behind them attacked (plates 25–33). Most carry crossbows with a range of 200 metres. The soldiers in Pit 3 wear two different types of armour: a lighter mail suitable for rapid movement and a heavier suit for close combat (plates 56–58, 81–83).

In Pit 2 there are kneeling archers in armour (plates 85 & 86) surrounded by unarmoured spear carriers. None of the warriors have shields but they carry various types of weapon (see pp. 74–77).

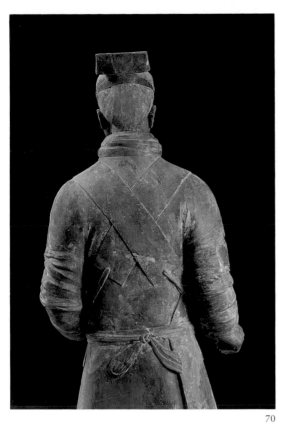

70

71. Charioteer, Pit 2

This plate shows the rear view of the charioteer in plate 42. The distinctive armour which protects the neck and the arms is clearly seen.

70. Middle-ranking officer, Pit 2

This officer was found at the south-west corner of the archers forming part of unit 1. His armour is fastened at the waist with crossed belts painted with fine geometric patterns.

71

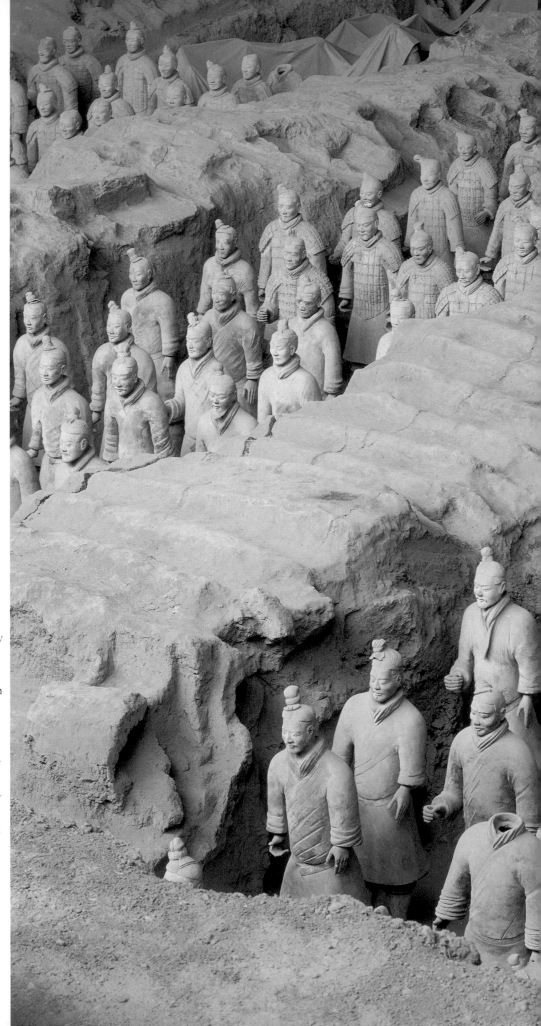

72. Warriors in the sixth and seventh columns, Pit 1

Sixty terracotta soldiers have been unearthed in the sixth corridor in Pit 1. Thirty-two wear armour while the remainder wear only robes. They are all armed. The traces of a four-horse chariot were found in the seventh corridor on which rode a charioteer, an assistant charioteer and a middle-ranking officer. Of the 44 soldiers in this column, those in front of the chariot are wearing only robes, while those behind are clad in armour.

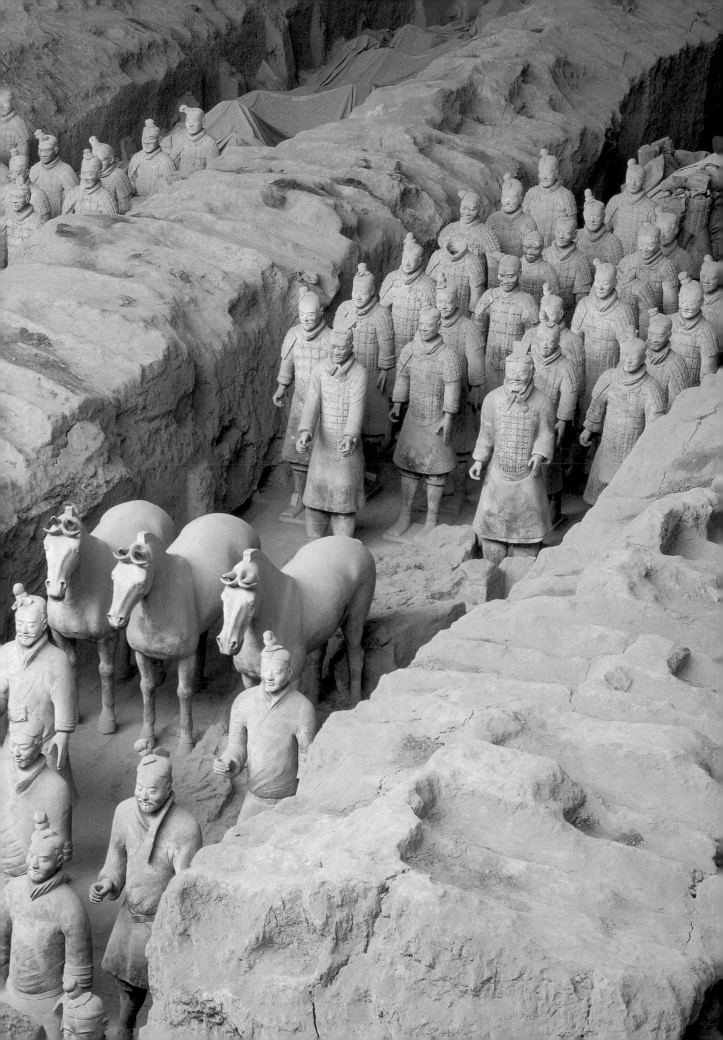

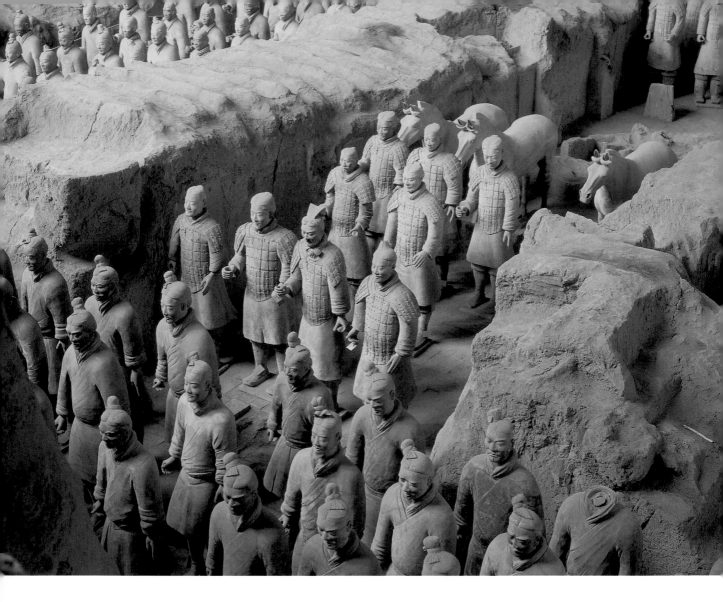

**73. Warriors in the eighth and
ninth columns of Pit 1**
According to the histories, a
large part of the Qin army
fought without helmets and
some without armour while the
soldiers of other states wore
both. The discovery of so many
soldiers without helmets in this
pit supports the historical record.

74. Rear view of infantry in the eighth column, Pit 1

This column contains 32 soldiers at the front dressed in robes and 28 behind in armour. The four officers are distinguished by their caps. Many of the soldiers wear their hair in complicated top-knots. The hair at the temples was divided and made into two plaits which were then fixed to the long hair at the back which was also made into a long plait. The remaining hair on top of the head and the long plait were then made into a bun on the top of the head, generally to the right (see overleaf).

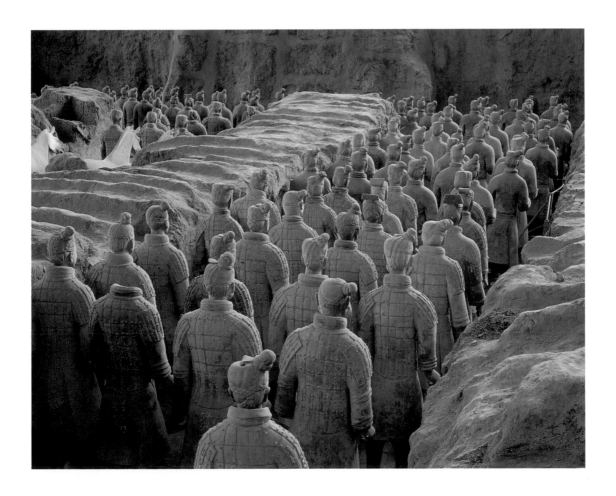

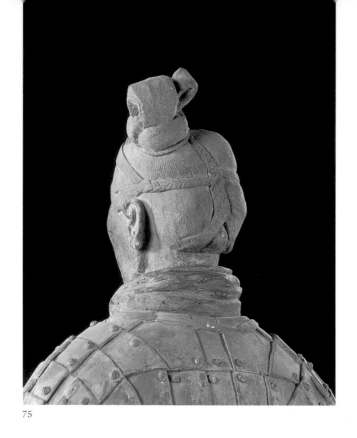

75

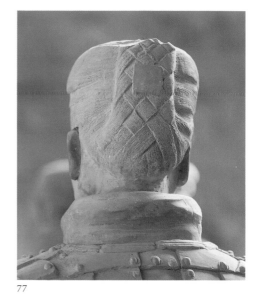

77

78

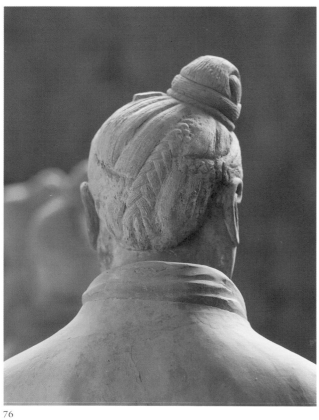

76

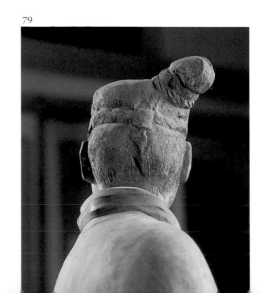

79

75–79. Hairstyles of the terracotta warriors

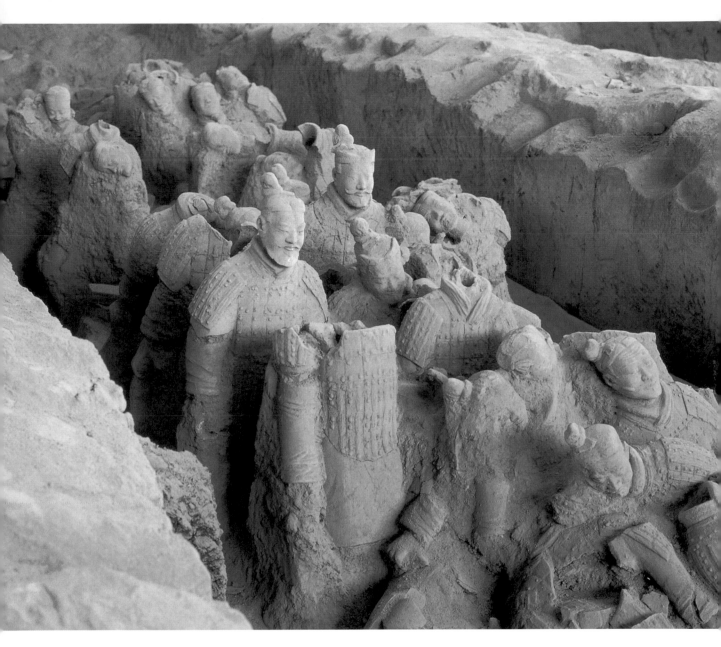

80. Terracotta figures under excavation in Pit 1

From the damaged remains of the terracotta soldiers the method of manufacturing can be inferred. The head and hands were made in moulds and then individually sculpted. The body was made separately using a lump of clay for the legs and lower torso. The upper torso was built up using coils of clay. The parts were then fitted together.

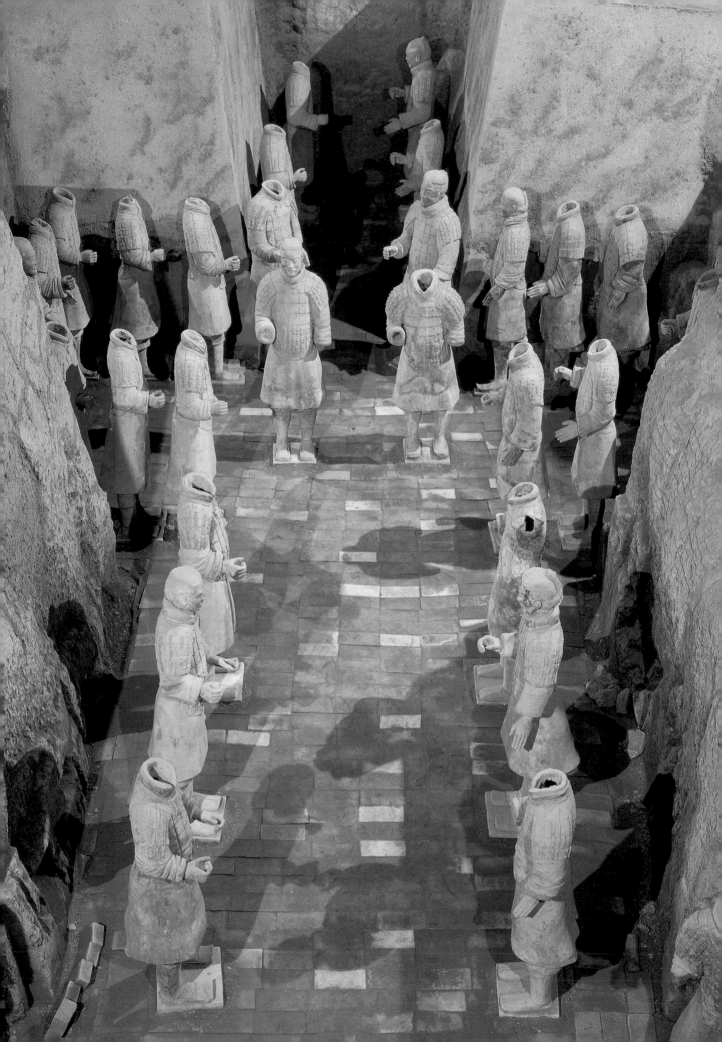

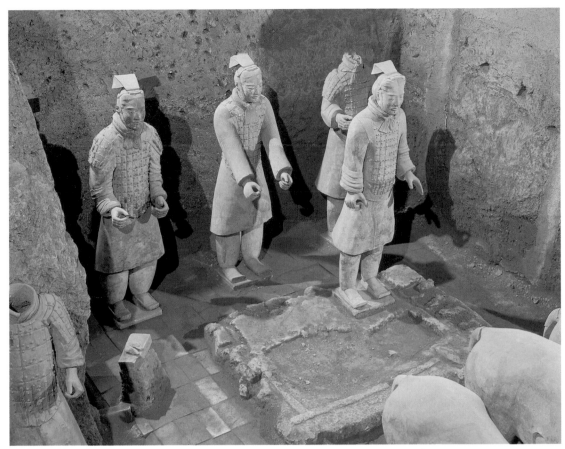

82

81. (*opposite*)
Warriors in Pit 3
The picture shows the
corridor and south chamber
of Pit 3 in which an armed
guard was discovered.

**82. Figures behind the
chariot in Pit 3**
The figure at the front is
1.9 metres tall and his cap
and dress indicate that he is
a middle-ranking officer.
The charioteer, flanked by
two soldiers, stands behind.

**83. A suit of armour from
Pit 3**
Traces of red on the scales
of the armour can clearly
be seen.

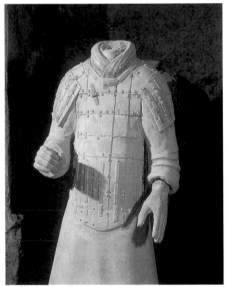

83

84. Standing archer, Pit 1

The archer was found in the eleventh column of Pit 1. Unlike many of the warriors, his pose suggests movement with the left leg placed forward and at right angles to the other and his head also facing forward, although the hips show no rotation.

85 & 86. (*below and opposite*)
Kneeling archer, Pit 2 (rear and front views)

From the centre of the archers in unit 1, this kneeling figure, 1.2 metres tall, wears a long robe, armour and shin guards, and was holding a crossbow. His hair is fastened in a bun to the left.

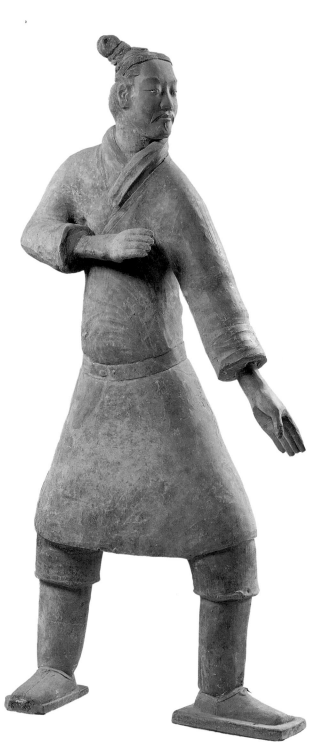

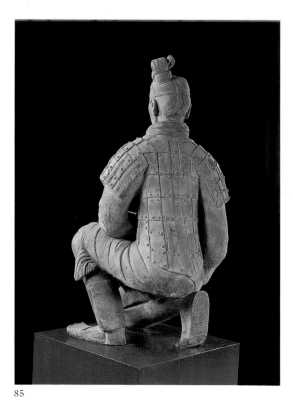

85

Not only can the age and mood of the soldiers be seen from their facial expressions (plates 87–91), but their faces also represent soldiers from different parts of China. Those with broad faces, a wide forehead and full lips, for example, are believed to depict soldiers from west Shaanxi province. Facial types common to what is now the south-west province of Sichuan and to the north-west of China can also be differentiated.

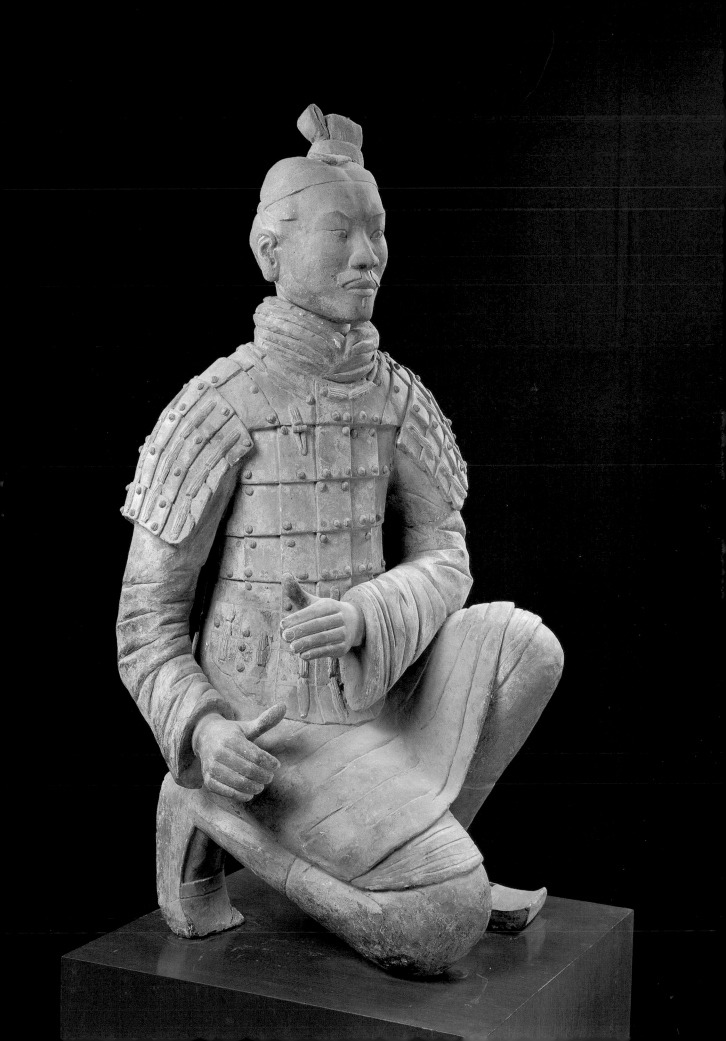

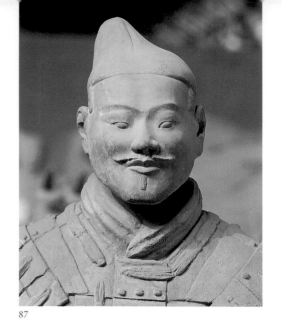

87

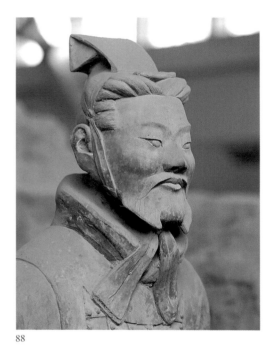

88

The sculpture of horses involved even greater skill (plates 47, 48, 92–94). Both the terracotta and bronze horses (see p.74 plates 121 & 128) have sharp featured square heads, with pricked ears and open mouths. They stand one and half metres high and two metres long and have broad shoulders and chest and a large croup.

Contemporary histories record that cavalry were first used in battle by the Chinese in the late fourth century BC. Horses were

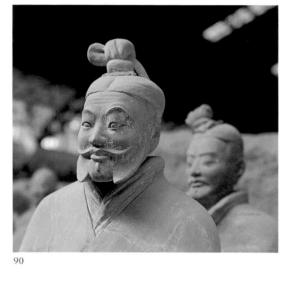

90

89

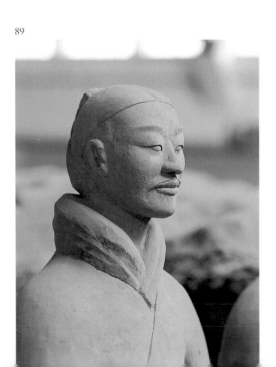

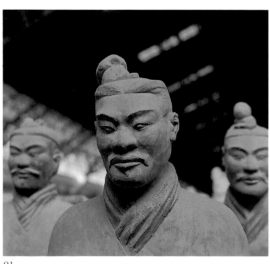

91

87–91. Facial expressions of the terracotta warriors

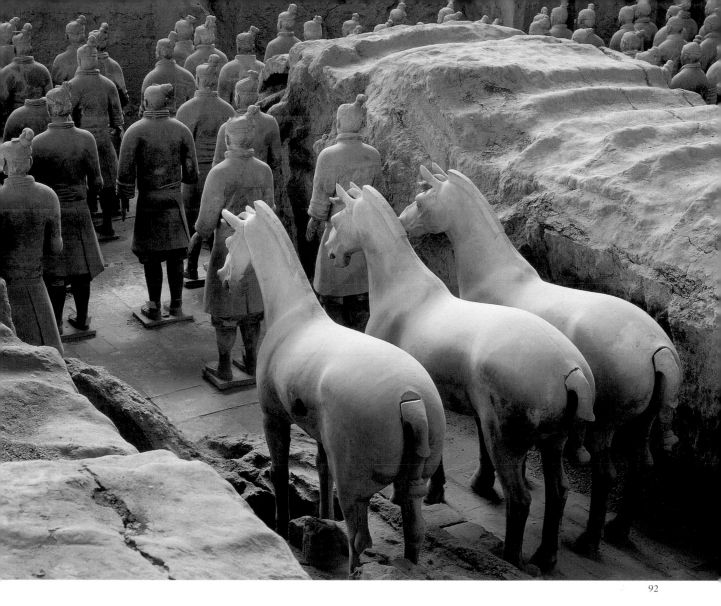

92. Rear view of horses, Pit 1

The temperature of the kiln is essential when firing. If too low the surface will lack sheen and the inside may not be fully fired. If too high, the horse is liable to break or become distorted. The plate shows an air vent on the left-hand side of one horse. The hole also allowed more heat to enter the hollow body and ensure the even firing of both inside and outside.

93. Side view of horse, Pit 1

This horse was found in the third column of Pit 1 and is about 2.10 metres long and 1.72 metres high. From paint remaining on its body and on the ground nearby it seems as if it was painted predominantly red.

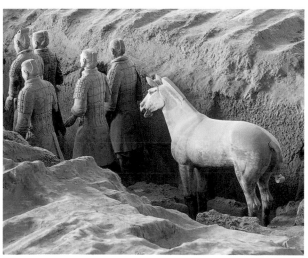

93

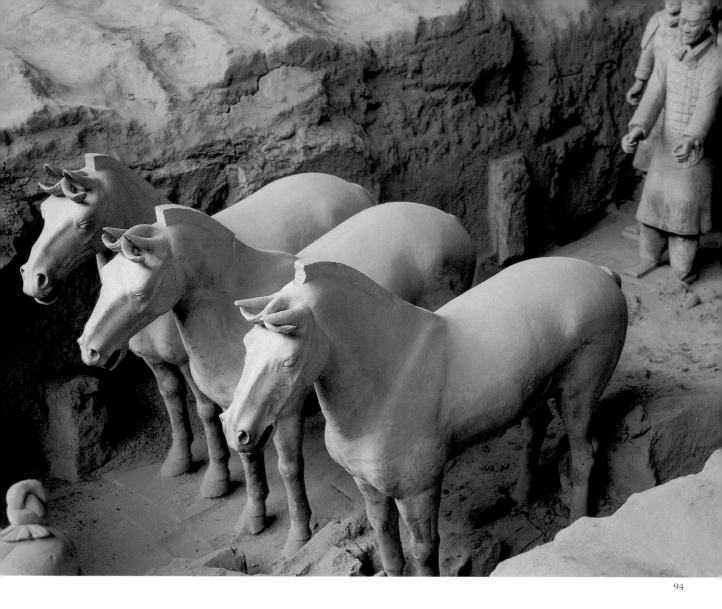

94

94. Horses, Pit 1
The horses' tails are tied up
to prevent them getting tan-
gled in the harness traces.
Although the remains of the
chariot show it to be the type
drawn by four horses, only
three have been found.

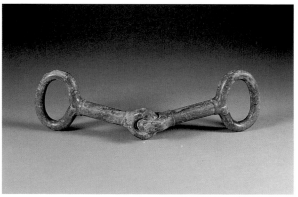

95

95. Bronze bridle from Pit 1

96. (*right*) **Decorative gold piece from Pit 1**
Bridles were decorated with gold pieces such as this convex disk, 4.69cm in diameter.

97. (*below*) **Duck-billed bronze hook from Pit 1**
This hook, 5.9 cm long, is part of the harness traces of a chariot from Pit 1.

98. (*below right*) **Bronze halter pieces from Pit 1**

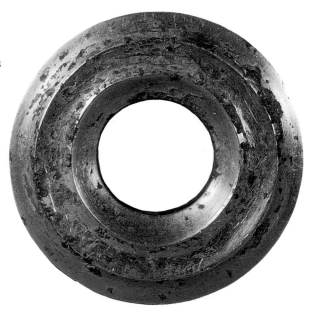

97

98

primarily bred on the steppes to the north-west of China and were small, sturdy Mongolian ponies. It was only later with the introduction of horses from Ferghana and other places in Central Asia that larger horses were bred and kept by the Chinese armies, although they were still mainly pastured on the Mongolian grasslands.

The cavalry horses are saddled and wear bronze bridles with a snaffle-type bit (plate 95). The chariots were made of wood and only traces remain (plates 99 & 100) although there is a reproduction in the exhibition halls. The terracotta horses were hitched to the chariots by wooden

shoulder yokes fixed to a crossbar and their tails are tied up to keep them clear of the harness traces (plate 92). The chariot had a single, central shaft and two wheels almost two metres in diameter. The chariot box had railings on each side. The chariot in Pit 3 also shows traces of a canopy and decoration.

The terracotta figures were originally painted, although most of the paint has now peeled off or faded. Chemical analysis of the remaining flakes shows that the warriors' hands and faces were painted pink, their sleeves and collar were green and brown, their robes green and blue, the

99. Traces of a chariot, Pit 1
The traces of half a chariot wheel can be seen in the earth. The wheel had 30 spokes and was 1.35 metres in diameter, with a hub about 50 cm in length.

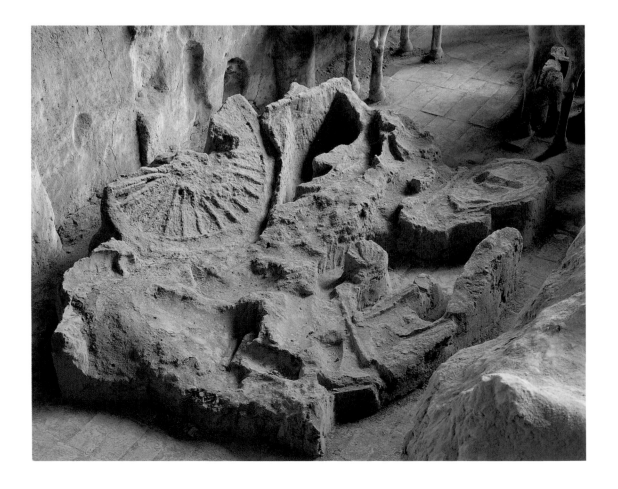

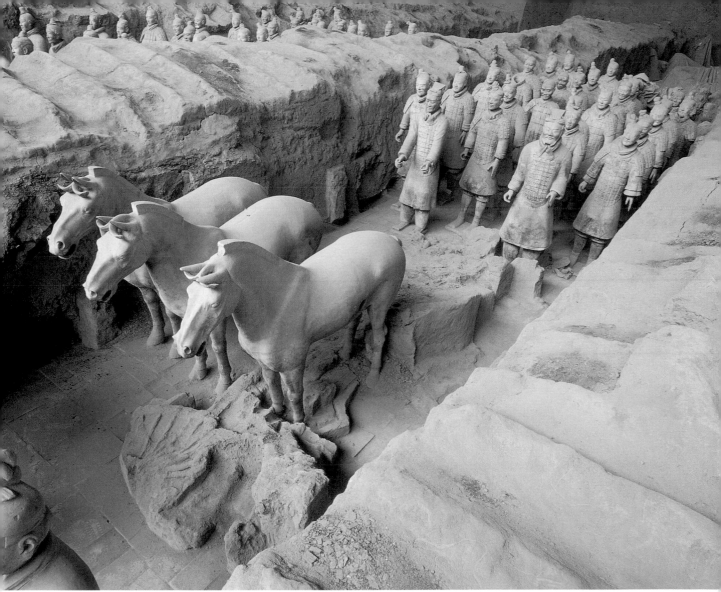

100

100 & 101. Chariots and horses, Pit 1

Only traces of the carriage, shafts and wheels remain. One of the wheels of the chariot shown above appears to have been moved to the front of the horses before the pit caved in.

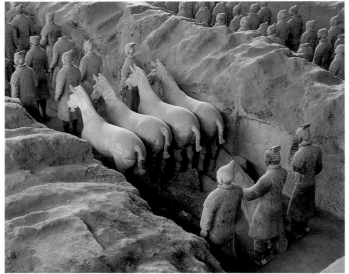

101

102. Colour imprints on the wall of Pit 3
The northern wall of Pit 3 retains traces of colour where the painted warriors were leaning. The black is from the armour, the red from the belt and the green from the robe.

rivets in the armour were black (plate 102) and the join of the armour was red (plate 83). The horses were brown with white eyeballs and black pupils, white teeth, red mouth and tongue. Traces of paint on some warriors' faces and chests can still be seen.

The bodies of the statues, which show a degree of standardization, were manufactured separately from coarse grey clay. From the abdomen down, the figures are solid, supporting the weight of the hollow torso and head. The horses also have hollow bodies supported by solid legs.

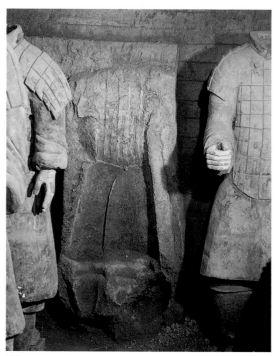

102

103. Structure of the pits
Pits 1 and 2 are divided into corridors by rammed earth walls and lined with wooden pillars which also supported the wooden roof. The warriors and horses were placed in the corridors.

103

70

104. Belt buckle of a warrior, Pit 1

All the warriors wear robes which are tied with a belt. The buckles are various shapes. The one shown here is unique. It depicts a warrior thrusting forward with a spear on the end of which is a human head. The spear forms the prong of the buckle and passes through a hole in the other end of the belt, held in place by the 'head'.

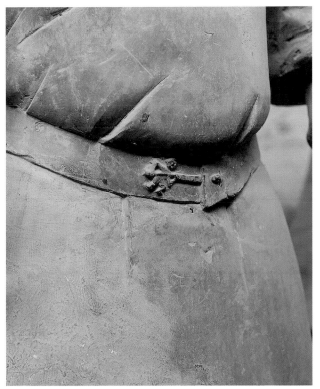

104

105. Sole of the shoe of a kneeling archer, Pit 2

One of the most striking features about the terracotta army is the combination of scale with attention to detail. Thousands of figures were sculpted yet all bear individual features, from their facial expressions down to their belt buckles. Even the stippled tread of this archer's shoe has been sculpted, showing the difference in tread on the heel, sole and instep.

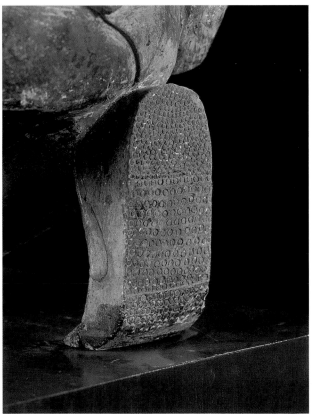

105

Research indicates that the sculptures were made by a process combining the use of moulds and handmodelling (plates 106 & 107). Different parts of the figure were moulded separately and finished off by hand, then baked and painted. The footboard was made first. The legs and lower part of the body were modelled from a solid lump of clay and then the upper torso added using the coiling technique so that it was hollow. The arms, hands, ears and heads were made separately from different - moulds, sometimes two moulds being used for the heads. The two parts of the head and the ears were then joined and finished off by hand and the whole figure was fitted together. Finally the clay figure was baked in a kiln and painted.

106 & 107 (*below*)
Process of making the terracotta warriors and horses
These tableaux recreate the process of manufacture of the terracotta warriors (*top*) and horses (*below*).

108 & 109 (*opposite*)
Characters on the backs of the terracotta warriors, Pit 1
Characters were found on the backs of all the terracotta warriors giving the name of the potter. The first two give the name of his place of origin and the last his first name. Altogether 85 different names were found in the three pits, including those of potters from the imperial workshops — denoted by the characters of the imperial capital 'Xianyang' — and others.

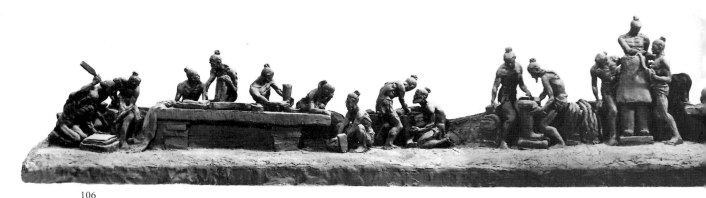

106

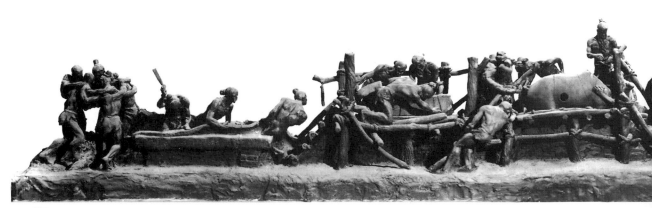

107

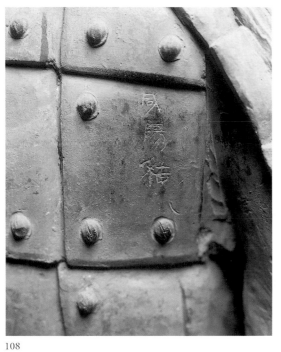

108

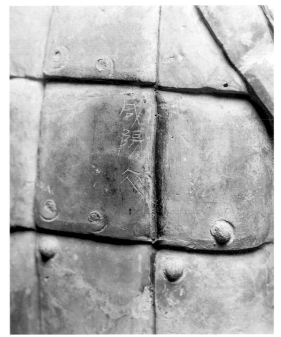

109

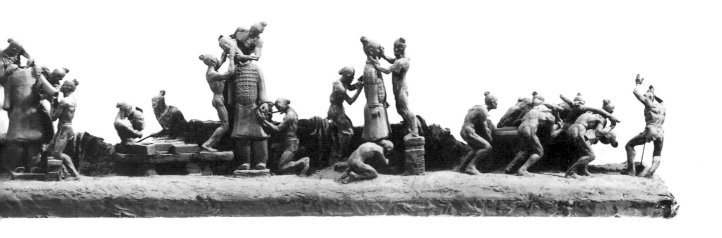

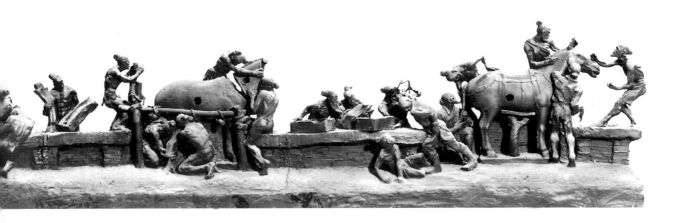

The warriors are inscribed with characters which indicate the provenance and name of the sculptor (plates 108–109). Some, for example, simply bear the two characters 'Xianyang' — the capital of the Qin — denoting that they were made in the imperial workshops. Others give a third character which is the first name of the sculptor. Not all of the sculptors were from the imperial workshops.

The horses were also made in several parts. Their hollow bodies were made from flat pieces of clay fitted together and fixed to the solid legs while the clay was still wet. The heads, tails, ears, manes and forelocks were also fixed on at this stage. One or two holes of seven to eleven cm diameter were left in the side of the body probably to act as an air vent during firing (plate 92). These were then plugged.

ANCIENT WEAPONS

Although only sections of the three pits have been excavated, about 300,000 weapons of various kinds have been discovered to date. Most of the weapons are bronze and were for use in battle, although some ceremonial weapons were found in Pit 3. When excavated, some were still sharp enough to cut a hair and many are engraved with fine characters in small seal script (the standardized form of writing Chinese characters implemented by Qin Shi Huangdi), indicating the date of production and the name of the maker. Swords (plate 110), curved knives (plate 111), dagger-axes (plate 112), battle-axes, spears (plate 113), halberds (a combination of a dagger-axe and spear), long lances (plate 114), crossbows and bows have all been found although the wooden sections have mainly rotted away or been burnt in the devastation wrecked by the rebelling peasants. Only the trigger mechanisms of the crossbows remain. Many arrowheads (plates 12 & 115) and a bronze sheath were also discovered.

Bronze metallurgy developed very early in China. A book on metallurgy written in the Warring States Period (481–221 BC) sums up the development of bronze metallurgy since ancient times and provides a description of the different proportions of copper and tin in different weapons. Another ancient work tells the story of the fifth-century king of Wu, He Lu, who ordered Gan Jiang, a famous sword maker, to cast him a fine sword. Three months passed but Gan Jiang was still unable to

110. Bronze sword, Pit 1

Measuring 92.8 cm in length with a 71 cm blade, 3.2 cm at its widest part, this sword was still bright and sharp when unearthed after 2,000 years of burial.

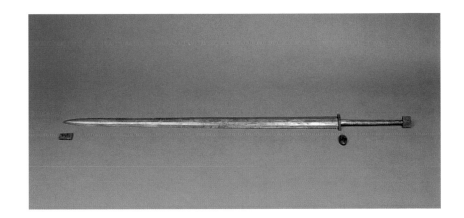

111. Curved knife

The curved knife was a popular weapon in the middle of the first millennium BC in China. This example is 71.2 cm long and 2.3–3.3 cm wide.

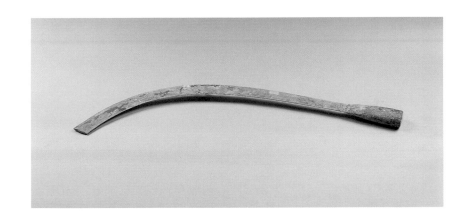

112. Bronze dagger-axe from Pit 1

This weapon is still extremely sharp. The inner side is incised with Chinese characters which name the makers and their supervisor. It is 26.7 cm long.

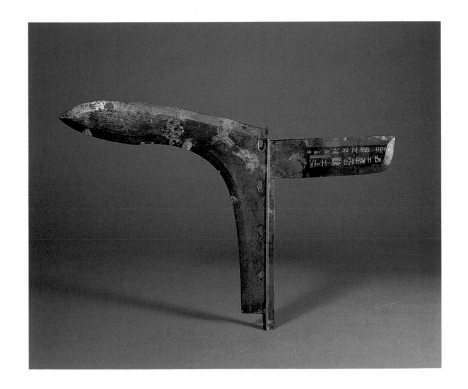

114. Bronze lance from Pit 1

Found in the second corridor of Pit 1, this lance-head is 35.4 cm long with a blade of 23.6 cm. It would have been attached to a wooden or bamboo handle.

113. Bronze spear from Pit 1

The blade of this spear is of a different type from that shown in plate 114. It is 15.4 cm and has a ridge running down the middle with grooves on either side. The blade has a diamond cross-section. The stem, which has an oval cross-section, is pierced for fixing on the handle using a bronze nail.

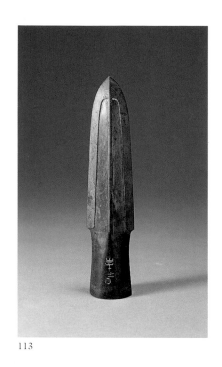

113

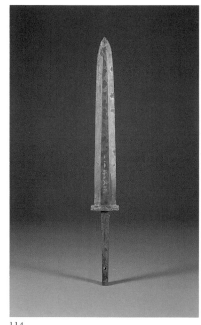

114

115. Flat bronze arrowheads from Pit 1

Only five bronze arrowheads have been found in Pit 1. They are 3.3–3.4 cm long.

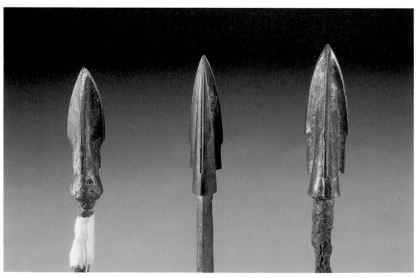

115

produce metal of a suitably high standard. Finally his wife Mo Xie cut off her long hair and her finger nails and added them to the furnace. These proved to be the essential ingredients and two magic swords were cast. These were much sharper than weapons made previously. It has been suggested that this story is connected with the invention of steel in China, although there is not yet any archaeological evidence to support this early dating.

Metallurgical technology developed further in the Qin dynasty. Chemical analysis shows that the bronze swords unearthed from the three pits are an alloy of 74 per cent copper and 22 per cent tin, with over ten other elements. The high tin content made the bronze as hard as tempered carbon steel. The swords were coated with chromium to prevent rust (plate 110). The arrowheads contain 7.71 per cent lead making them very effective.

THE STRUCTURE OF THE UNDERGROUND PITS

The structure of the three pits is similar although they are different shapes and sizes and serve different purposes. A huge hole was dug for Pit 1, 16,000 square metres in area and five metres deep. The earth at the bottom and sides was then rammed to make it flat and hard. Ten two metre high walls made of rammed earth were built from east to west, thereby dividing the pit into eleven corridors (plates 18, 25–33, 52, 117). Rammed earth was used extensively in Qin architecture and the remains of the Qin Imperial Palace can still be seen to the north of Xi'an. An extant section of the foundations of the Epang Palace, part of the new palace grounds started in 212 BC which had a circumference of over 144 kilometres, comprise a rammed earth platform over six metres high and covering an area of over 450,000 square metres.

The floors of the corridors of Pit 1 were paved with dark blue Qin bricks in four sizes which are decorated with fine rope patterns (plate 116). Five sloping earthen ramps leading to the pit were constructed at the eastern and western ends. The corridors were lined with wooden pillars which were placed in grooves at the foot of the walls (plates 14, 59). When the warriors and horses were in place, logs and earth were used to seal the entrances. Wooden beams were laid across the pillars and partition walls. Planks were placed densely over the beams and these were covered with woven reed mats, clay and then earth up to ground level. Therefore the terracotta

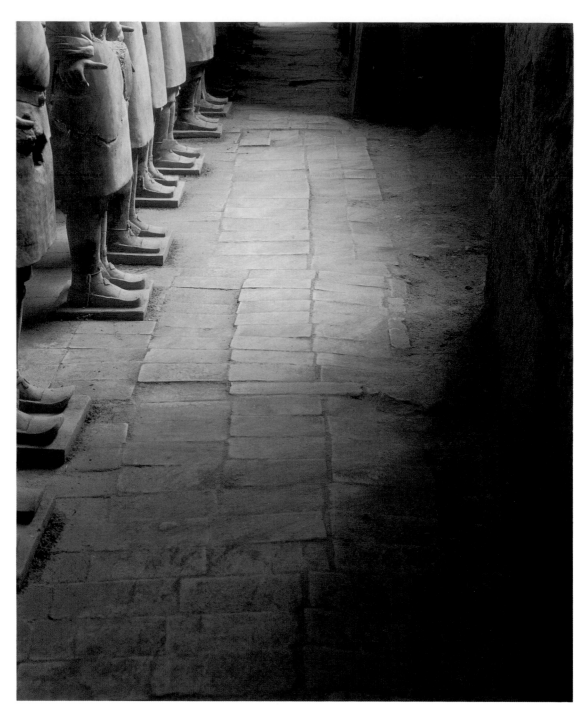

116. Brick-paved floor in Pit 1
The floor of Pit 1 is paved with
bricks in four different sizes
decorated with a rope pattern.

117. Brick wall in Pit 1
The original rammed earth wall in the south-east corner of Pit 1 partially collapsed during construction and was replaced with a brick wall. This is the earliest brick wall found to date in China.

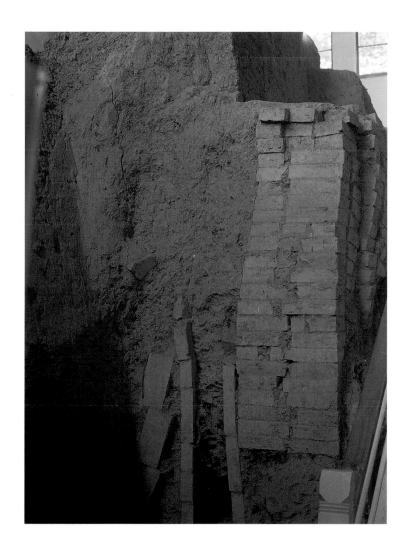

warriors and horses were buried deep underground. Here they may have remained undisturbed had the downfall of the Qin, only a few years later, not led to the structures being burnt and the wooden roofs collapsing onto the terracotta figures, all of which resulted in extensive damage (plates 13 & 14).

118. Wooden pillars in Pit 2

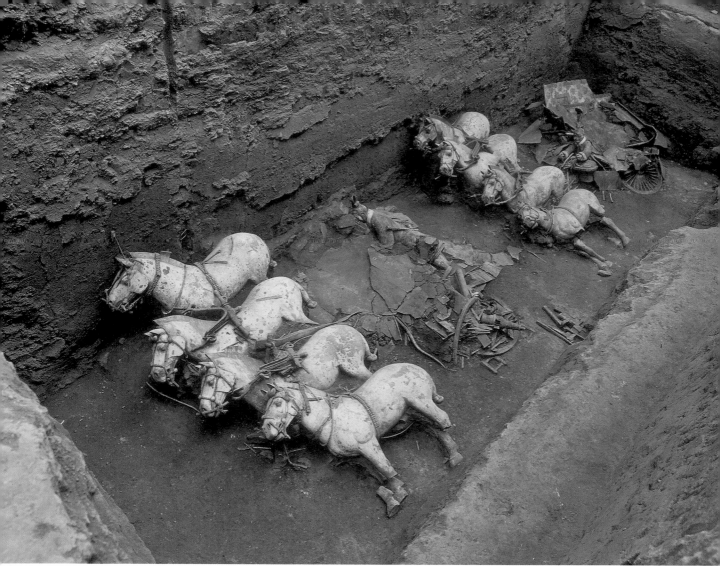

119

119 & 120
(*above and opposite*)
Excavation of the bronze chariots
Two large painted bronze chariots were discovered in 1980 just to the west of the burial mound of Qin Shi Huangdi. Each has a charioteer and is drawn by four horses. They were badly damaged at the time of discovery but have since been restored and are now on show in a special exhibition hall.

80

The Imperial Bronze Horses and Chariots

In order to consolidate the newly established empire and to search for an elixir of immortality from the mythical Eastern Isles, Qin Shi Huangdi made five 'tours of inspection' after unifying China, four of them to the east and south-east (he died while on the fifth tour). Whenever he went on such a tour there would be a mighty procession of extravagant chariots which drew admiration from those who saw them (although the tours were dreaded by the local peasants and officials who would have to provide the emperor and his entourage with provisions).

After the discovery of the Qin terracotta warriors and horses, archaeologists turned their attention to the emperor's mausoleum. They explored the vicinity of

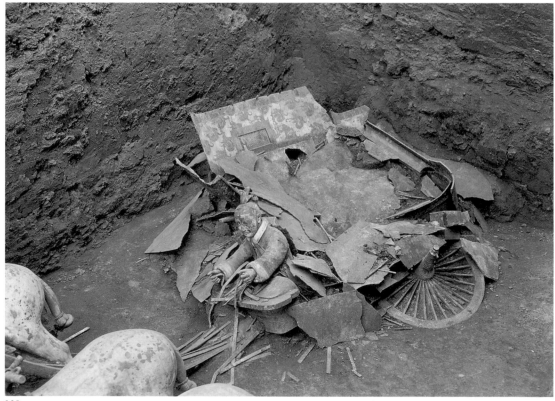

120

the tomb mound and their perseverance finally yielded results. In 1978 they discovered bronze objects just west of the grave mound which proved to be parts of chariots and harnesses. It was surmised that there must be a pit containing horse-drawn chariots nearby. They continued their excavation through the bitter winter of 1980 until they discovered the actual pit.

The pit containing the bronze chariots and horses is an earth-and-wood underground structure with a total area of 3,000 square metres. It is divided into four sections from north to south. The bronze chariots and horses are located in the second section which contains five corridors. Two teams of bronze chariots drawn by four horses were excavated from the first corridor. They were originally named according to their position in the pit, the front one being called Chariot 1 (plate 121), and the one behind Chariot 2 (plate 128). They are now usually referred to by their different functions: the former being called either a standing chariot or a war chariot and the latter a peace or passenger chariot.

The bronze chariots and horses had been reduced to fragments following the collapse of the pits (plate 119) and archaeologists were confronted with the painstaking task of rebuilding them. Work started in 1981 and within two years the war chariot and the horses had been restored and put on public show. By 1988 the other chariot had also been restored and put on show.

Both teams of chariots and horses are about half life-size and elaborately decorated in keeping with their role as chariots of the imperial guard and retinue. The body of the war chariot is rectangular, 48.5 centimetres long and 70 centimetres wide, measuring 2.25 metres long in total including the harnessed horses (plates 121–22). A bronze umbrella 1.14 metres high is erected in the body of the chariot, which stands 1.68 metres from the ground to the top. The canopy of the umbrella has a diameter of 1.22 metres, 22 ribs, gold-inlaid geometric designs along the edges and painted dragon designs on the inner side. There are gold and silver-inlaid scrolled cloud designs on the upper and

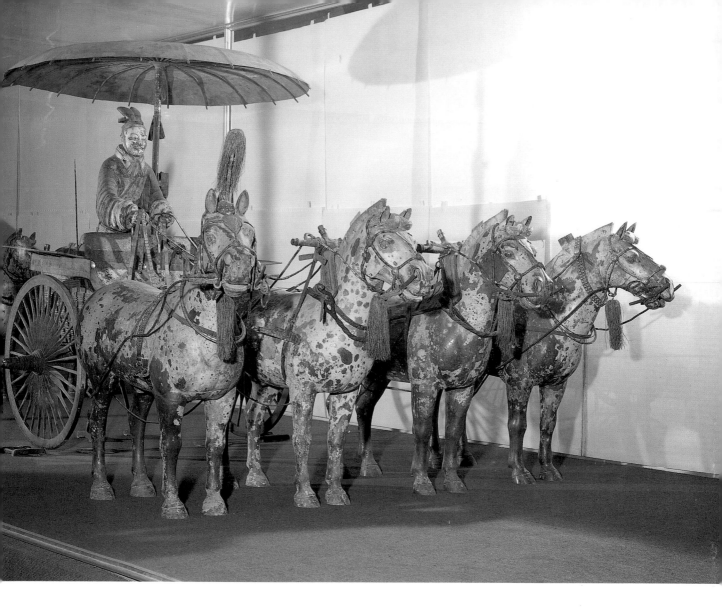

121. War chariot

This chariot, 1.68 metres tall, has a door at the back and is covered by a canopy. The chariot contains various weapons — a bronze shield and case, arrow quiver and crossbow — indicating its function as a war chariot for the imperial guards.

middle section of the umbrella pole. The bottom of the pole is inserted into a pedestal. There are rails on both sides, the inner faces of which are painted with coloured rhombic patterns and the outer faces with geometric lines. Across the front is a cross bar for the guards to hold and it is also decorated on both faces. The chariot is open at the back to enable people to get on and off. The coach has room for three people, but contains only the charioteer (plate 122). He stands under the umbrella dressed in a long robe and cap like that of the terracotta generals, armed with a sword and holding the reins in both hands. A crossbow (plates 122–24) hangs at the front of the chariot body and there is also a bronze quiver holding 54 bronze arrowheads hanging on the inside of the crossbar (plates 122, 127). A shield case holding a bronze shield is placed on the inside of the left rail. Both sides of the shield bear painted geometric designs (plates 125–26).

The passenger chariot is slightly longer at 3.17 metres in length and 1.06 metres high (plate 128). The body of the chariot is divided into front and rear chambers. The front chamber has room for only one charioteer. He is 51 centimetres tall and dressed in a long robe with the distinctive charioteer's cap. He wears a sword at his waist and his face and hands are painted pink and his hair dark. His robe is painted sky-blue with dark borders and sleeves decorated with red geometric patterns. There are also designs on the handle and sheath of his sword. Different parts of the chariot body are painted with a coloured ground overlaid with decorative patterns.

The rear chamber is for the passenger and there is room for him to sit or lie comfortably, although the rear chamber of this chariot is empty (plate 130). The rear chamber is completely enclosed with windows on both sides and to the front and back. The sliding side windows can be opened and shut depending on the weather. The door at the back is elaborately decorated on both sides with dragons and on the inner side only with

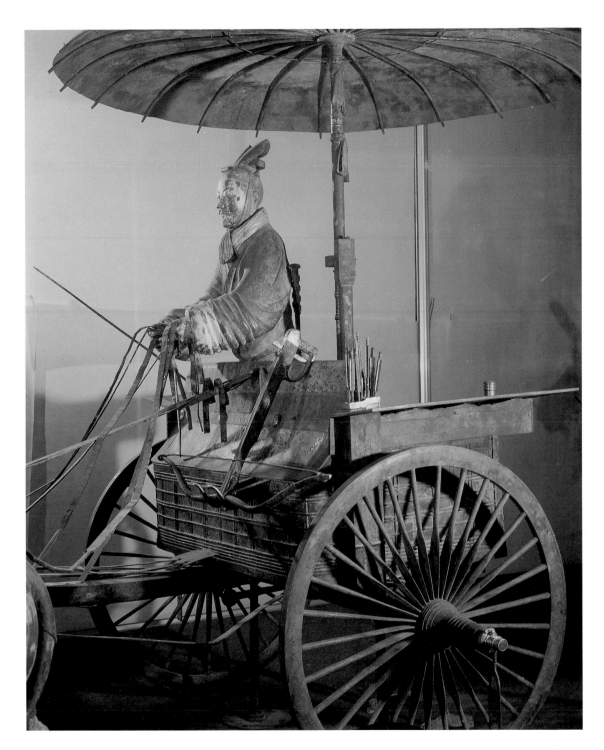

122. War chariot

At the front of the chariot is a cross bar
on which the crossbow hangs. The
quiver of arrows was found hanging on
the inside of the side rails. The gold
and silver designs on the handle of the
canopy can also be seen here.

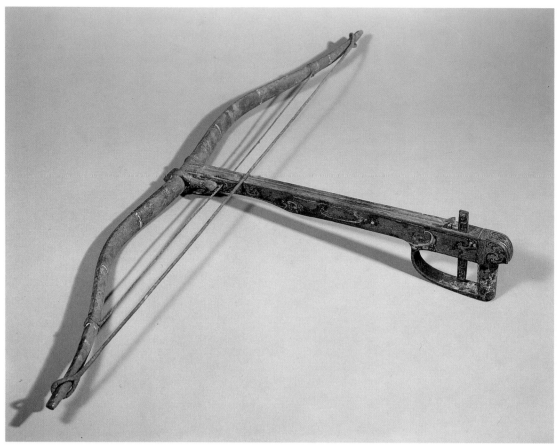

123

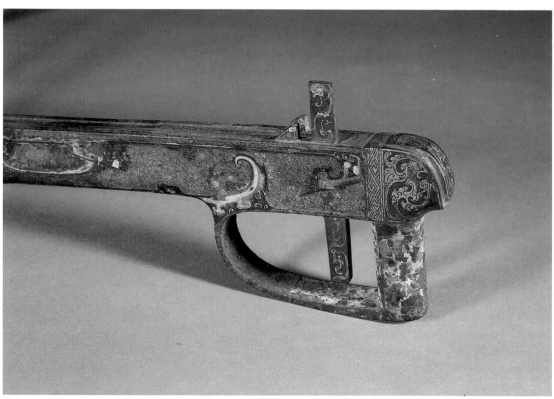

124

123 & 124. (*opposite*)
Bronze crossbow
This complete crossbow was
found on the war chariot.
The bow measures 70.2 cm
long, the bowstring 66 cm
and the stock is 39.2 cm.

125 & 126. (*below*)
Bronze shield
The pictures show the outer
and inner faces of the bronze
shield found in a case on the
war chariot. It is the best
preserved Qin dynasty shield
discovered. It is divided into
two sections by a central
ridge. There is a handle on
the inner side. Both sides are
painted with a symmetrical
design of two dragons.

125

126

127. Arrows in a quiver

This rectangular quiver, found on the war chariot, contains 54 bronze arrows. The quiver is painted and has a lid. The arrows are of two different kinds: diamond-shaped and flat. The diamond-shaped arrows are 35.2 cm long, while the flat-headed ones are 35.4 cm with the head measuring 2.2 cm. The quiver is 38 cm long, 5.4 cm wide and 11.8 cm high.

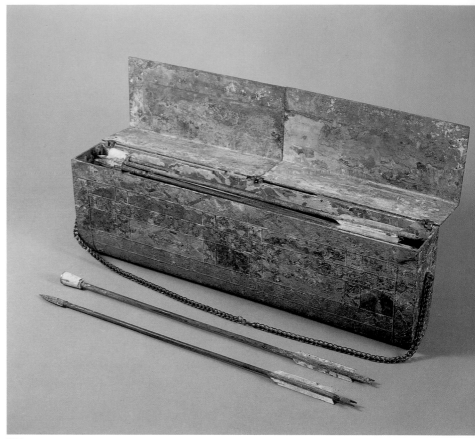

127

128. Passenger chariot

This chariot has two chambers: the front one for the charioteer and the rear one for the passenger, although in this example the rear chamber is empty. The rear chamber is enclosed but has sliding windows to provide ventilation.

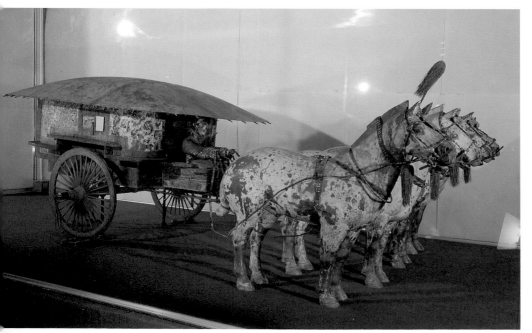

128

129. Charioteer on the passenger chariot
The charioteer sits in the front chamber holding the reins in both hands. He is 51 cm tall and wears a sword at his waist.

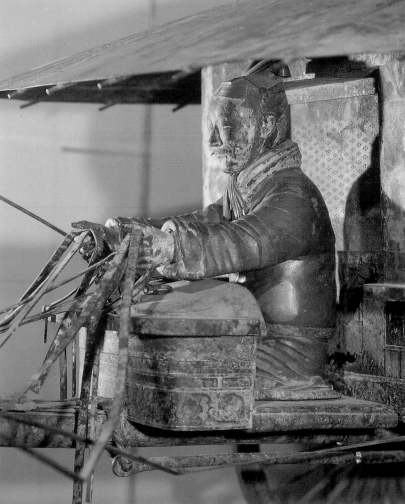

129

130. Interior of the passenger chariot
The comfortable interior of this chariot supports the view that it was for use in peace and was not a battle chariot like those discovered in the terracotta pits. It has a canopy and elaborate painted decorations on both the inside and outside.

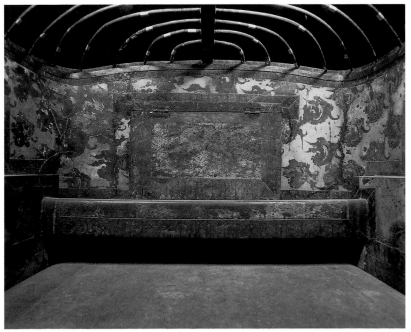

130

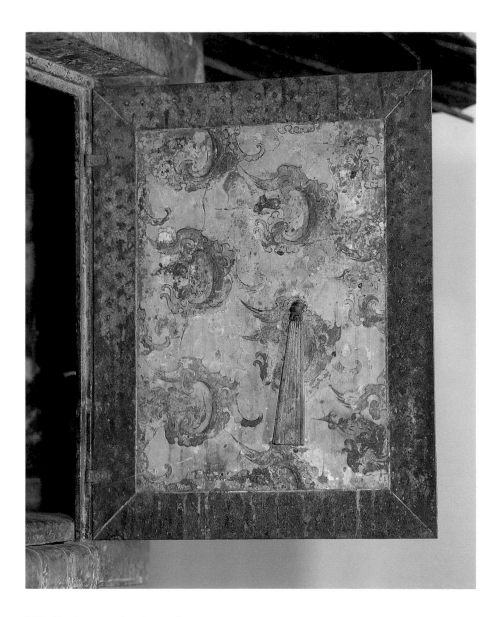

131. Designs on the door of the passenger chariot
Both sides of the door are painted with beautiful designs. This picture shows those on the inside which comprise dragons and phoenixes.

phoenixes (plate 131). The chariot weighs 1,241 kilograms. The wheels have a diameter of 59 centimetres and the hub is 29.4 centimetres long (plate 133). The hubs of passenger chariots were long as they had to support heavy weights. Those of war chariots were kept as short as possible so that they were not easily broken when in collision with other chariots in battle. Because of its unwieldiness, the chariot was replaced more and more by cavalry in

132. Bridle parts
The picture shows various parts of the bronze bridles worn by the horses of both chariots.

132

133

133. Wheel of the passenger chariot
The 30-spoke wheel has a diameter of 59 cm and a hub 29.4 cm long.

battle, although the finds in Pits 1–3 show that at this period the chariot was still very important.

The two bronze chariots are similar in many ways. They are both single-shaft, four-horse, two-wheel and 30-spoke chariots. The bronze horses of both are painted white with red tongues and nostrils. The structure of the chariots represents ancient Chinese cosmology which depicts Heaven as round (the round canopy of the chariot) and earth as square (the square coach of the chariot). The thirty-day cycle of the moon is represented by the 30 spokes of the wheel (plate 133). Both teams of horses have gold plaques on their foreheads and tassels made of fine bronze wire hanging from the bottom of the bridles in front of their necks. Their bridles and reins are made of bronze with jointed gold and silver tubes (plate 132). The chariot traces and reins are made of jointed copper tubes and flat copper pieces.

The bronze is an alloy of copper, tin and lead with other elements in much smaller proportions. The bronze chariots and horses weigh over 2,000 kilograms and are composed of about 6,000 parts. The manufacture of such large bronze items consisting of so many large and small parts must have required complicated and highly developed metallurgical technology. Different components were made using different techniques — casting, welding, riveting, inlaying, embedding and loose joining. They show the high level of bronze craftsmanship in Qin dynasty China.

The bronze chariots are reproductions of Qin imperial chariots, and their discovery has provided invaluable information to supplement the written and graphic record. The histories describe the procession which accompanied Qin Shi Huangdi on his tours of inspection as consisting of 81 imperial chariots, 36 chariots for the retinue, and others for the high officials. The procession would have been accompanied by music and drum beats, with soldiers and cavalry riding ahead to clear the way.

Apart from the exhibition halls for the three pits containing the terracotta warriors and horses and the exhibition room for the bronze chariots and horses, there are several other exhibition rooms at the museum. They provide an introduction to the history of the excavations and display individual warriors, horses and weapons along with other Qin dynasty artefacts to give visitors a better understanding of the context of these remarkable finds.

List of Plates

Index